IMAGES
of America
MICHIGAN STATE
FERRIES

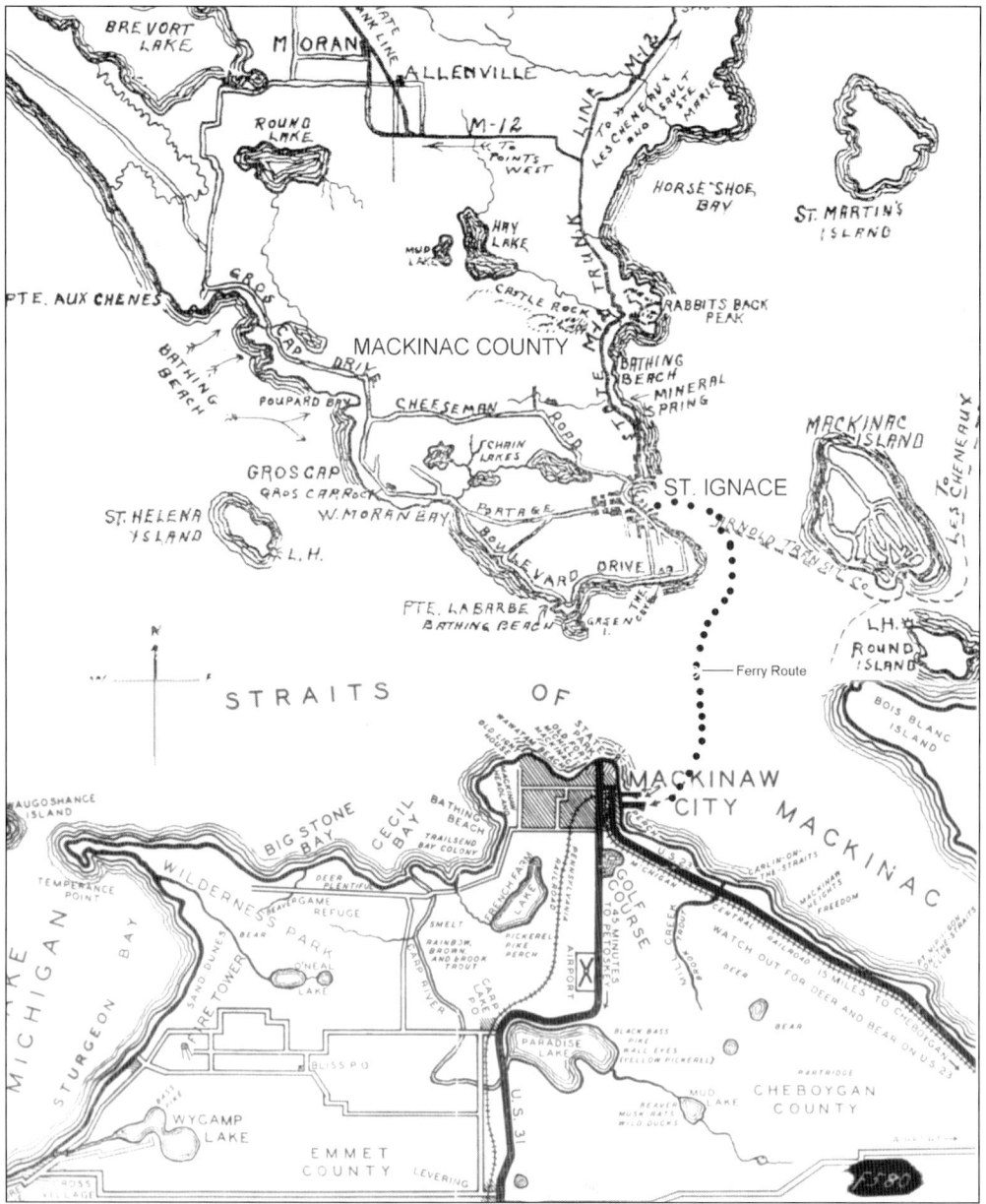

As better roads reached the Straits of Mackinac, more motorists clamored to cross between Michigan's Upper and Lower Peninsulas. This is a composite map from several sources, which includes the major ferry route between Mackinaw City on the south and St. Ignace on the north. To stay in deep enough water, the ferries had to avoid striking North Graham Shoal.

On the cover: On the eve of World War II, the Mackinaw City dockmaster (far right) adjusts the ramp, and cars drive off the Michigan state ferry *City of Munising*. Foot passengers stand ready to board for the next 40-minute crossing to the Upper Peninsula. This is one of a series of postcard photographs taken that day published by the L. L. Cook Company of Milwaukee. (Author's collection.)

IMAGES of America
MICHIGAN STATE FERRIES

Les Bagley

Copyright © 2007 by Les Bagley
ISBN 978-0-7385-5068-8

Published by Arcadia Publishing
Charleston SC, Chicago IL, Portsmouth NH, San Francisco CA

Printed in the United States of America

Library of Congress Catalog Card Number: 2007924632

For all general information contact Arcadia Publishing at:
Telephone 843-853-2070
Fax 843-853-0044
E-mail sales@arcadiapublishing.com
For customer service and orders:
Toll-Free 1-888-313-2665

Visit us on the Internet at www.arcadiapublishing.com

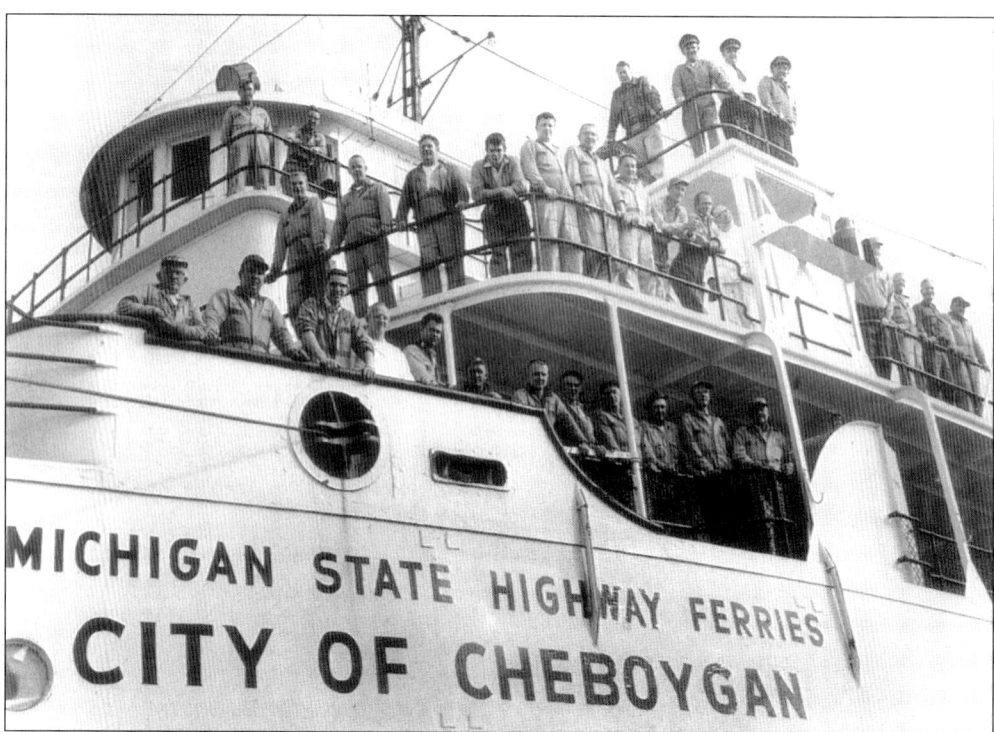

Hundreds of men and women worked and sailed for Michigan State ferries over the years, sometimes as many as 400 employees per season. They never all posed for a single photograph, so this one, of a *City of Cheboygan* crew under command of Capt. Pat Gallagher (in the white shirt on wing bridge), will have to represent them. This book is a tribute to them all. (Archie Cosens collection.)

Contents

Acknowledgments		6
Introduction		7
1.	The Earliest Ferries	9
2.	The First State Ferry	15
3.	The State Gets Serious	19
4.	Through the Depression	33
5.	The Ferries Grow Up	45
6.	World War II Downturn	77
7.	New Beginnings	83
8.	Vacationland	91
9.	Bridging the Gap	99
10.	Sailing Away	111

Acknowledgments

My parents, Dudley and Iola Bagley, took me across the straits on the new *Vacationland*. I was 4, and I was hooked. With my aunt Edrie Swift as instigator, they indulged this ferry addict for the rest of their lives.

I followed *Vacationland* through her subsequent careers while collecting photographs and memorabilia. I broke news of her sinking to Michigan papers, meeting journalist John Walters. Capt. Al White, of BC Ferries, invited me to show my collection at her "Reunion/Roast/Wake," and my friend, television producer Dave Wilson, made that slide show into a video. John showed the tape, and then introduced me to a gathering of Michigan State ferries retirees. He had planned to write their history himself, but died unexpectedly, passing the mantle to me.

This work would have been impossible without help from Bill Phillips, Michigan Department of Transportation Photo Lab; Mackinaw City librarian Judy Ranville; folks at the Michigan State Archives, Bentley Historical Library, Dossin Great Lakes Museum, Mackinac Bridge Authority, and Mackinac Bridge Museum; and contributions from collectors like Dave Christiansen, Al Hart, Michael Leon, Chuck Truscott, and others. All reasonable efforts were taken to contact appropriate copyright holders before using their work but through time and multiple sources, many original photographer and publisher credits have been lost. For this I am truly sorry.

Librarians in Cheboygan, Detroit, Milwaukee, and New Jersey provided photographs and files, as did the Cleveland *Plain Dealer, Detroit News,* and Wes Maurer at the *St. Ignace News*. He also serialized my text history of Michigan State ferries in his newspaper, while Lake Michigan car-ferry historian Art Chavez introduced me to Arcadia Publishing and editor Anna Wilson.

I cannot say enough good about St. Ignace librarian Cindy Patton. She went well beyond normal duty to speed long-distance research.

Many people personally shared memories and photographs, particularly ferry ex-crewmen Archie Cosens, Jim Jonas, and Mickey Sweeney. Charles Ziegler's daughter Barbara, Daisy Fredrickson Butler, and Carson Dalton Jr. also welcomed me into their homes and shared rare family records.

Then there is *Vacationland* mate Jerry Cronan who became much more than an invaluable resource—he has become a great friend and inspiration. Thank-you all!

Introduction

Every year for half a century, millions of motorists have breezed between Michigan's peninsulas on the Mackinac Bridge, slowing to enjoy the view, and pausing only briefly at the toll plaza. Forty years before, drivers of the earliest motorcars found a far different crossing. Thirty years before that, a formal crossing did not even exist.

The Straits of Mackinac (pronounced "Mack-in-aw") has long been a waterway for commerce. Native people traded by canoe between Lakes Michigan and Huron, crossing east and west through the straits. But few people crossed north and south between the peninsulas. The native tribes living in the southeastern Upper Peninsula used the 5-mile gap as protection against surprise attacks from hostile bands to the south.

In the 1600s, Jesuit missionaries used the straits as a gateway to explore and expand Christianity, and in the 1700s, Europeans made it the centerpiece of America's thriving fur trade. But still traffic flowed east and west, not north and south. Only footpaths pierced the upper Michigan wilderness.

The valuable fur trade required military protection, and a succession of forts were built, first on one side of the straits, then on the other, and finally on Mackinac Island in the middle. Communication between residents of each community necessitated the first informal straits crossings. But it was not until much later that a formal ferry service began.

The Erie Canal jump-started Midwest growth, and by the Civil War, hungry furnaces in lower lakes cities craved iron ore and copper, found in abundance near the Upper Peninsula's Lake Superior shore. The shallow rapids of the St. Mary's River at Sault Ste. Marie proved an obstacle to waterborne commerce. They were soon tamed by the Soo locks. But winter proved an even more formidable blockade. Contemporary bulk carriers could not transport enough each summer to last the mills through the winter when deep fields of ice locked everything in port.

The war between the states also brought railroads of age. By 1880, three had converged on the straits, two connecting Mackinaw City at the tip of the Lower Peninsula through the wilderness to Detroit and Chicago, and one providing land access from St. Ignace in the Upper Peninsula to the mineral deposits industry desired. But the short gap at the straits blocked continuous rail shipments as well.

Efforts to make St. Ignace an ore port to avoid the rapids, or make it a manufacturing center with a steel furnace, ultimately proved unsuccessful. The railroads had better luck filling the straits's gap with a ferry service. Beginning in 1880, their jointly owned Mackinac Transportation Company (MTC) formally crossed the waterway with a succession of railroad ferries. Raw materials, including ore and lumber, more easily flowed south. Manufactured goods

also returned north, along with legions of vacationers and sportsmen, attracted by crystal-clear waters, azure blue skies, cool summer temperatures, and miles of game-filled wilderness away from hot, crowded, industrial cities. Resorts and lodges appeared almost overnight, capped in 1887 by Mackinac Island's Grand Hotel.

At its dedication, Commodore Cornelius J. Vanderbilt called it the finest seasonal resort hotel in the nation, adding, all that was needed now, was a bridge across the straits. It was only a dream; the technology and economics of bridging the gap were years away. While steamships and steam engines connected the straits with the rest of the continent, railroad ferryboats maintained year-round travel between Michigan's two peninsulas.

Then the motorcar brought a fundamental change. Freed from tight railroad and steamship schedules, automobile travelers found they could readily explore more places on their own, and they demanded better roads, more services, and greater variety along the way. No longer would families book a resort hotel as a single summer destination. Sequential vacations moved folks farther down the road each night, giving rise to small, convenient motor hotels, or motels, and an infinite variety of roadside attractions to tempt wallets along the way. Attraction owners promoted heavily to lure business, and the increased advertising, better roads, and improved accommodations meant summer travel to northern Michigan boomed. So did the demand to carry automobiles across the straits.

At first plagued by archaic laws, the railroad ferries were slow to respond to the need. Their service was inconvenient, and prohibitively expensive. Although it got better with time, the precedent had been set, and voters demanded politicians fix the problem. Michigan responded in 1923, by creating Michigan State ferries, the first state-run highway ferry in the nation.

Operations were hesitant at first, out of concern that a seasonal automobile ferry would be cost prohibitive. Later the simmering dream of bridging the straits swayed long-range ferry decisions. But as roads improved and advertisers created more interest, summer traffic continued to build, spilling over into more demand the rest of the year. Michigan State ferries became a dominant force and the major employer in the region.

There were challenges. Michigan needed to connect both peninsulas all year, despite winter weather that closed roads and blocked the straits with wind-blown ice piled up to 40 feet deep. Many of the ferries and crew sat idle for lack of traffic most of the year, yet on busy summer weekends and during fall hunting season, motorists sometimes sat in 20-mile lines and endured daylong waits to cross. Tourists wanted more boats and faster service. Mackinac Islanders wanted the ferry to serve more places. Voters wanted improved connections for less money. Employees wanted more money for less work. And some politicians wanted to pursue their own agendas.

Yet for 34 years, until the Mackinac Bridge finally opened in 1957, Michigan State ferries provided the primary link between the peoples of Michigan. For many Midwesterners, it was a first ride on a big ship, a break in a long, hot summer drive, and a pleasant interlude to highlight an otherwise all-driving vacation. For many adult residents, college students, and local kids, it was a source of much-needed employment. And for everyone in Michigan, it was a way of life that has almost completely faded away, except through distant memories and photographs like these.

One
THE EARLIEST FERRIES

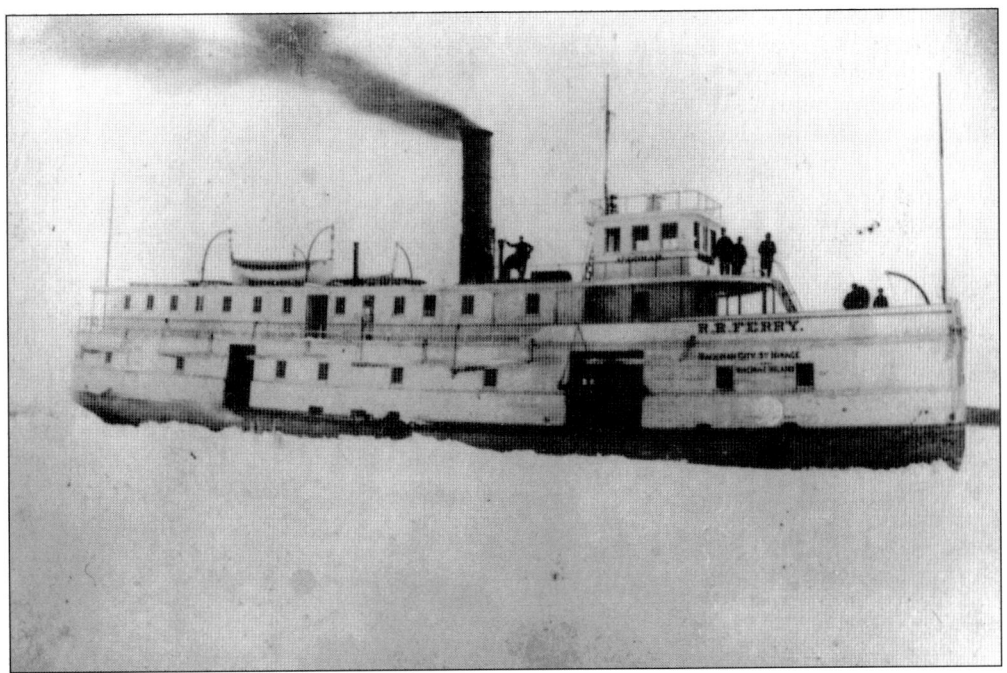

The wooden propeller *Algomah* inaugurated ferry service by Mackinac Transportation Company (MTC) in 1880. She was designed to carry passengers and less-than-carload (LCL) freight while towing four railroad cars on the open barge *Betsy*. Strengthened for moderate icebreaking, she proved to be an able boat most of the year, but the barge crew was exposed to the elements, and *Betsy* proved dangerous, if not impossible, to tow through the ice. (C. H. Truscott collection.)

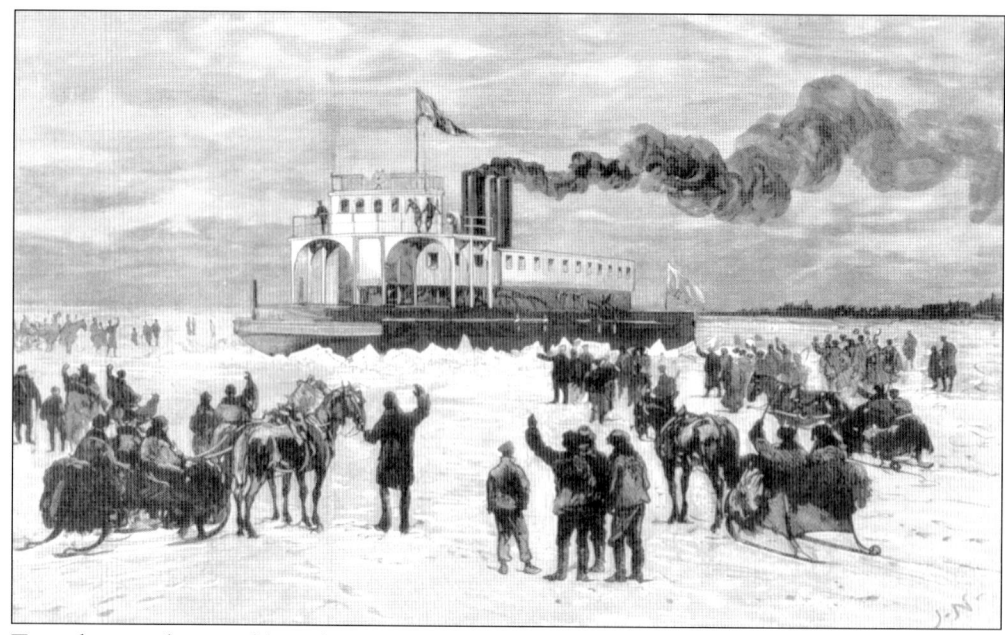

Transshipping bags and barrels of grain and ore and lumber by hand was slow and expensive. In 1888, MTC launched the *St. Ignace,* a 10-car wooden ferry with open sides and an enclosed center cabin. When she arrived at her namesake port in April, the populace surged onto the ice and a huge celebration ensued. People realized their long years of winter isolation had ended. (Author's collection.)

The *St. Ignace* presented a problem with her open car deck, and the line needed more capacity. In 1890, Frank Kirby designed the *Sainte Marie,* a larger wooden ship with an enclosed car deck. Powered by compound engines fore and aft, she proved a superb icebreaker. Her four funnels made her stand out among the ferries and steamships that called on the area. (Author's collection.)

Once the new 18-car, three-track ferry arrived at the straits in 1893, the two-track *St. Ignace* was withdrawn and sent to the shipyard where her car deck was enclosed. She was thereafter used as a spare boat, held in reserve while her larger sister did most of the daily work. (Michigan State Archives.)

Capt. Louis R. Boynton was the commodore of the MTC and an acknowledged expert at icebreaking. He commanded the *Algomah,* and brought out the *St. Ignace* and *Sainte Marie.* He is credited with the idea of using a bow propeller to suck water out from under the ice making it easier for the weight of the ship to crush it. (St. Ignace News.)

11

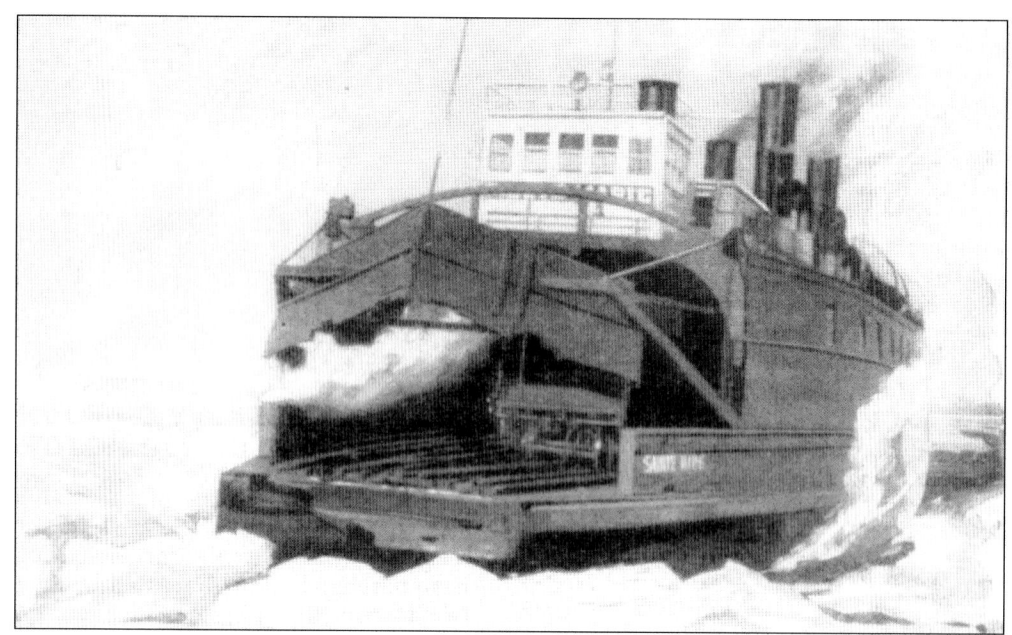

Boynton's ferries gained worldwide fame as icebreakers. The *Sainte Marie* was illustrated in *Popular Mechanics*, but the author misidentified her seagate, closed to keep waves from entering the otherwise open bow, instead calling it a "plow," lowered to split the ice. She actually worked by forcing her spoon-shaped forward hull up onto the ice, crushing it with her weight. (Author's collection.)

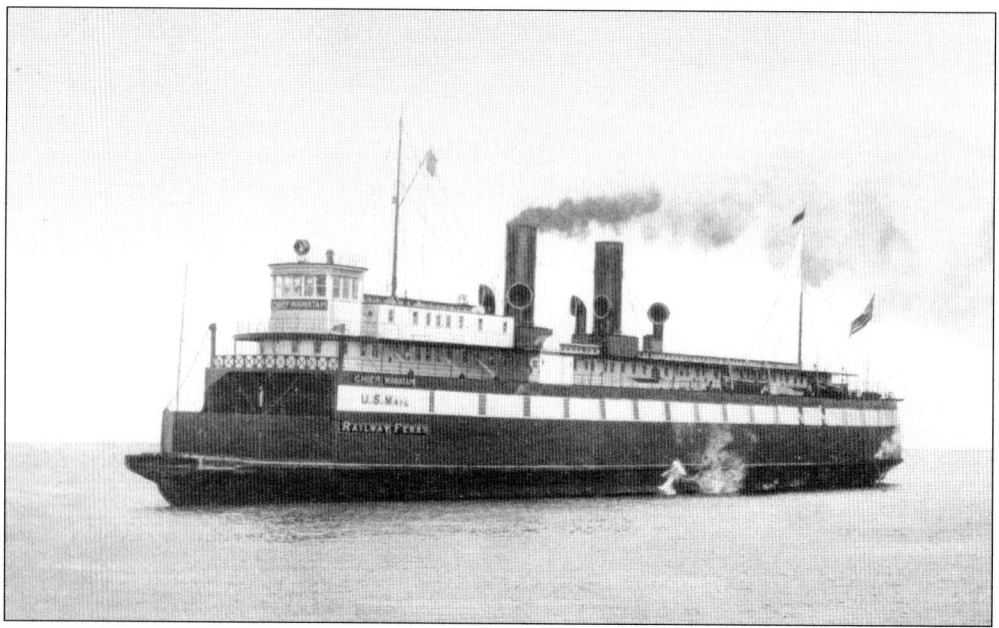

Impressed with lower maintenance costs of steel hulls used on Lake Michigan car ferries, MTC asked Frank Kirby to design the huge *Chief Wawatam* of 1911. The *Chief Wawatam* had two propellers aft, and one forward, all powered by triple expansion engines. When she entered service, the *Sainte Marie* was withdrawn and her engines removed for use in a new steel vessel of the same name. (Author's collection.)

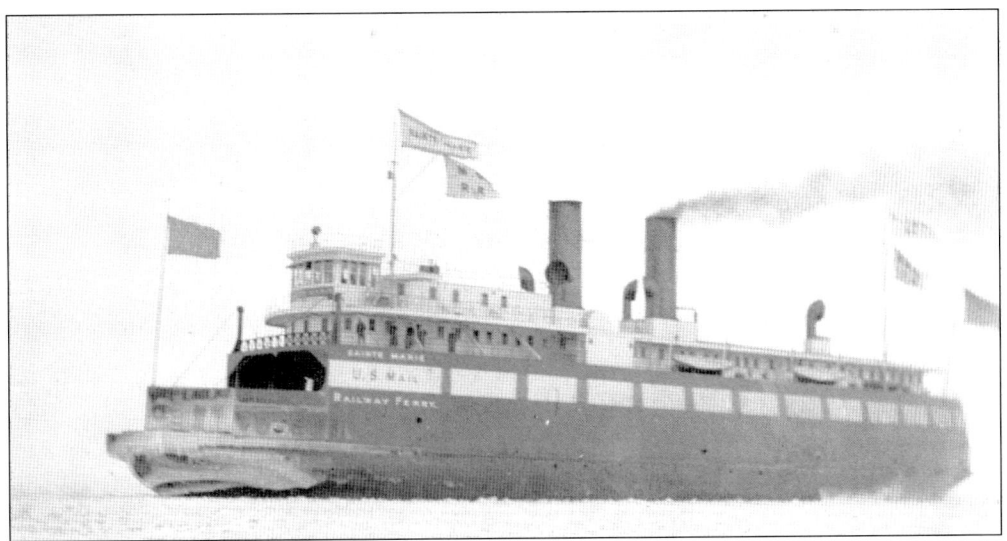

The second *Sainte Marie* was photographed when she entered service on March 17, 1913. Slightly smaller than the *Chief Wawatam*, she was still an excellent icebreaker, but only had one propeller at her stern, plus one on the bow, both driven by her predecessor's compound engines. With two steel ferries now available, the old wooden *St. Ignace* was retired. (Author's collection.)

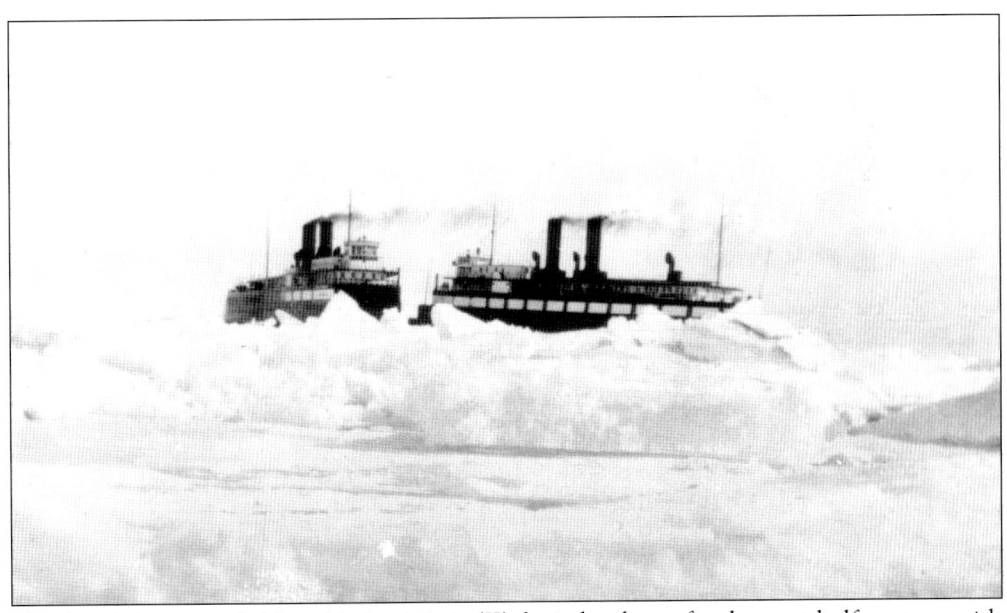

The *Chief Wawatam* (left) and *Sainte Marie* (II) ferried rail cars for the next half-century, with only minor interruptions. The *Chief Wawatam* handled about 85 percent of the work, while the smaller ferry was kept in reserve, usually operating with the *Chief Wawatam*'s crew unless under charter. The *Sainte Marie* (II) could be identified by the large ventilator atop her after cabin. The detail seen here is from a Raymond B. Desy postcard. (Author's collection.)

The first automobiles arrived at the straits in about 1908. At the tip of the Lower Peninsula, Mackinaw City became the end of the Dixie Highway, a hodgepodge routing extending to Florida. A stone monument marked the trail's end. But many drivers wanted to continue farther north, to the Canadian border at the Soo, and in 1917, the first automobiles were ferried across. (Author's collection.)

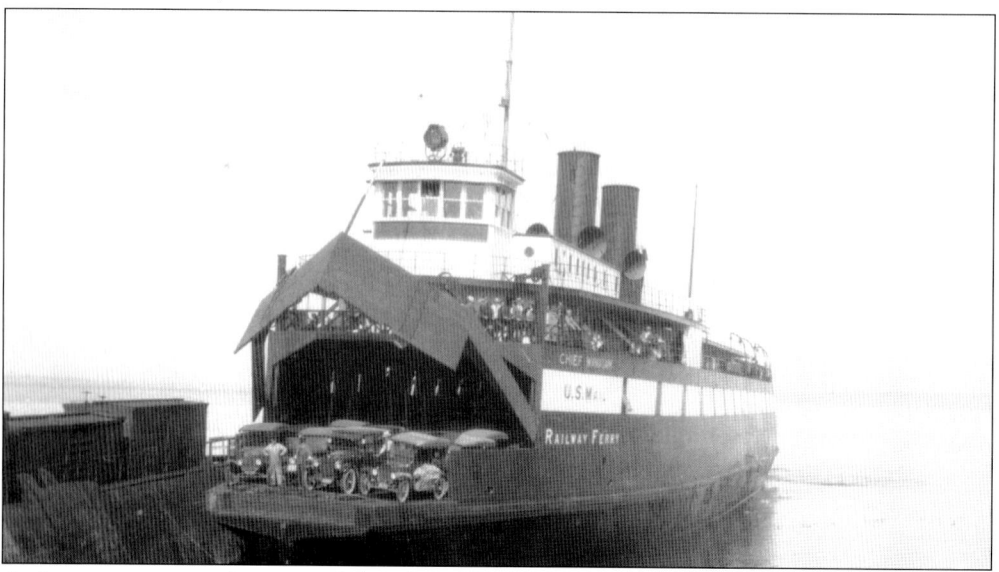

At first maritime regulations prohibited carrying explosive gasoline, so gas tanks were drained, and automobiles were pushed onto flatcars, and then switched aboard. MTC charged $40 for a crossing when a new Model T cost only $800. Later, with better fire extinguishers, cars were allowed to drive directly onboard, and prices came down. But in 1922, motorists still complained bitterly about the cost and MTC's service. (Author's collection.)

Two

THE FIRST STATE FERRY

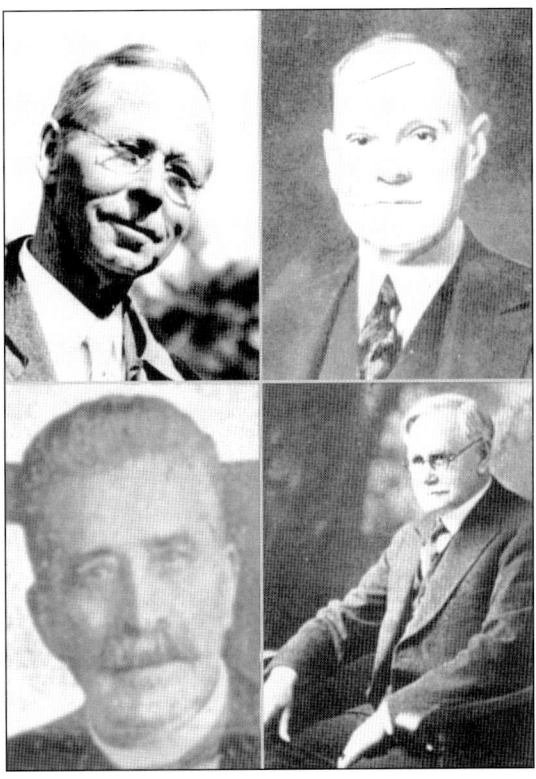

The Michigan State Highway Department began in 1909 under Horatio S. "Good Roads" Earle (upper left). By the 1920s, hundreds of ferry complaints had reached Gov. Alex Groesbeck (upper right), who asked legislators to approve a state-run ferry at the straits, and to designate highway commissioner Frank Rogers (lower right) to oversee it. Rogers engaged John Stevenson (lower left), an experienced Detroit politician and maritime man, to quickly hire people and find a boat. (Michigan Department of Transportation; below left, Detroit News.)

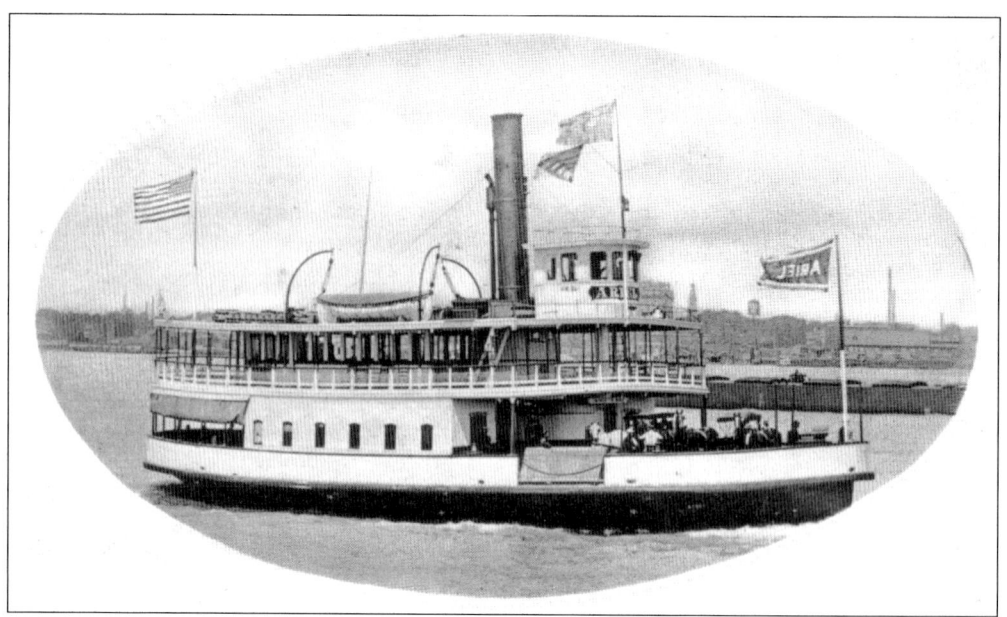

Started by distiller Hiram Walker, the Walkerville Ferry Company purchased its first new boat, the wooden-hulled *Ariel* (US 106032), from John Oades's Detroit shipyard in 1892. The ferry was 95 feet 10 inches long with a beam of 28 feet 9 inches. She was powered by a 90-horsepower Frontier Iron Works high-pressure steam engine. (Author's collection.)

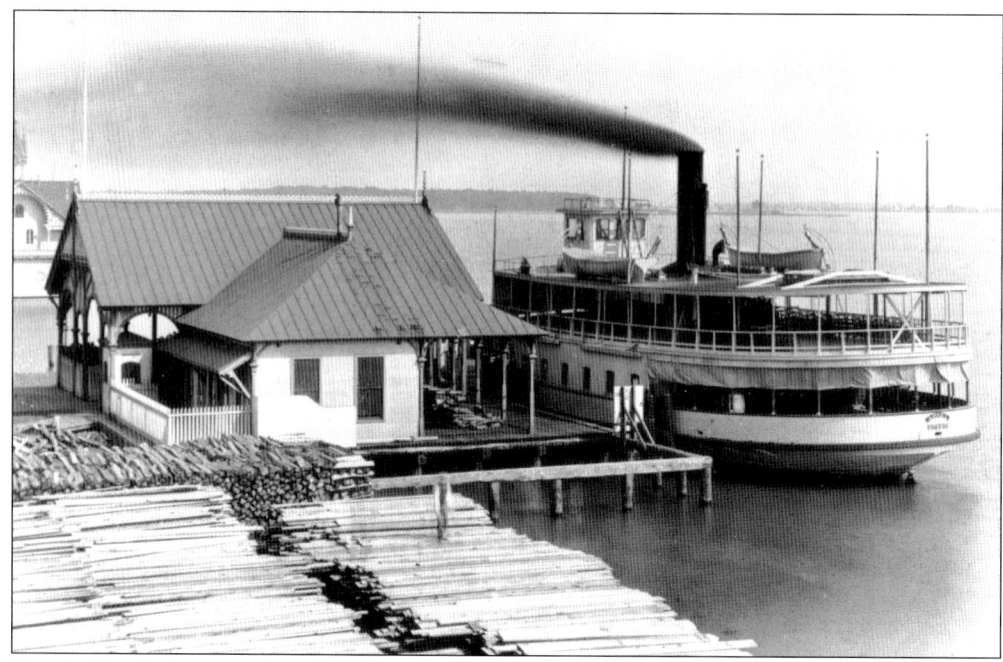

The *Ariel* sailed a route from East Detroit to Walkerville, Ontario, via Belle Isle, an island park in the Detroit River. The route took Canadians directly to the island, without backtracking upriver from an existing ferry landing and crossing on a bridge from the American side. The *Ariel* is shown here early in her career. (Detroit Public Library, Burton Collection.)

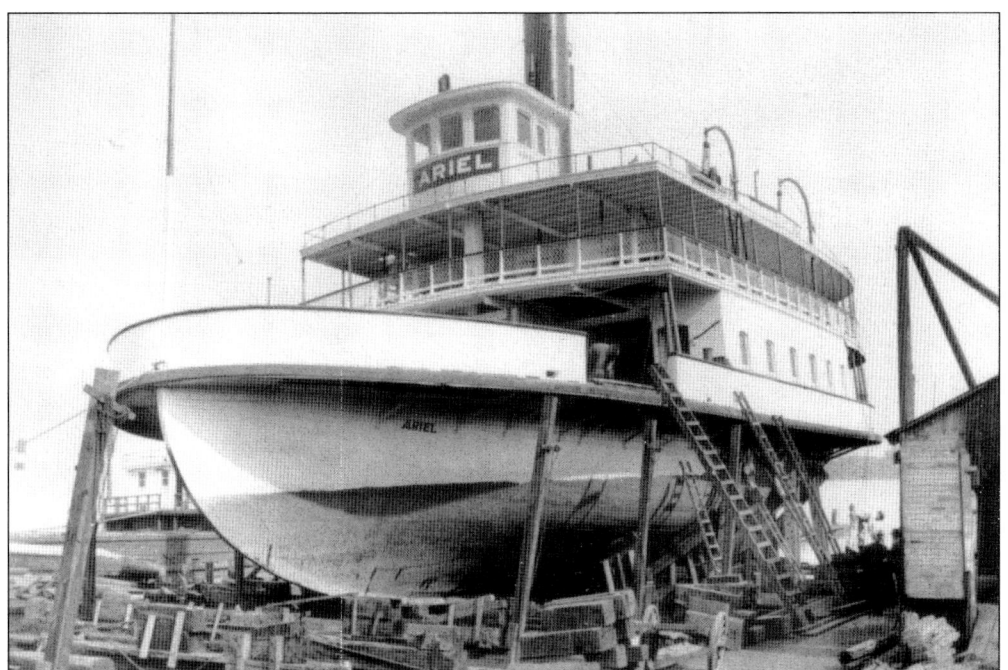

Then motorcars came on the scene. The ferry was enlarged to 110 feet by 36 feet in 1912, and some of her passenger cabins were removed for more room to carry automobiles. With a new boiler, her original engine now generated 550 horsepower. Following World War I, a new steel ferry replaced her, and the 41-year-old *Ariel* was laid up and offered for sale. (Steamship Historical Society; photograph by Oades Shipyard Photograph.)

John Stevenson recommended Michigan buy the *Ariel* for $10,000, and after modifications for seaworthiness, she sailed north and officially started state ferry service on August 6, 1923. Photographs of her in state service are very rare. She was not adequate for the job and was quickly replaced. And many views were destroyed in a fire at the highway department headquarters in 1951. (Michigan Department of Transportation.)

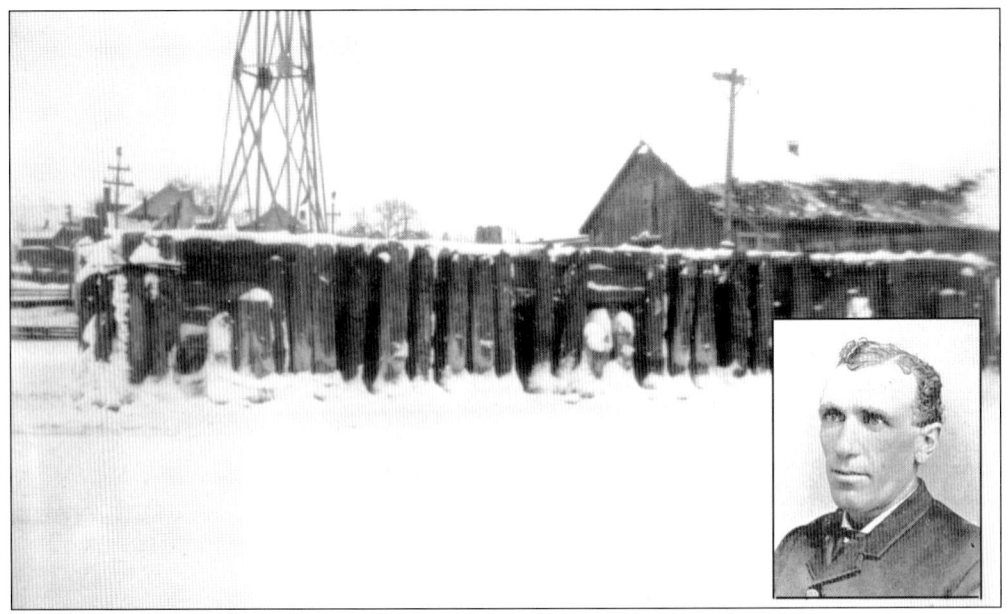

To operate the service, the state also needed ferry landings. After inspecting a number of St. Ignace locations, commissioner Frank Rogers purchased the Chambers Dock from the estate of John Chambers (inset). It was centrally located to the town's business district, and it had deep enough water to accommodate the *Ariel*. The state paid $10,000 for it, and renamed it the State Dock. (Michigan State Archives.)

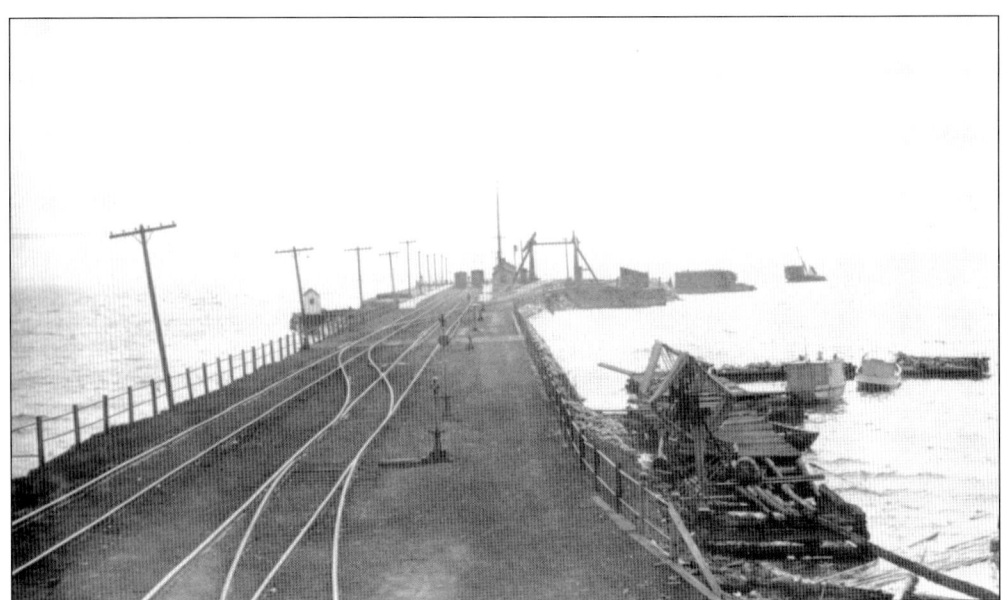

Finding nothing suitable for sale in Mackinaw City, Rogers leased space on the north side of the MTC's Railroad Dock. Some fill was added, planks were put across the tracks, and the *Ariel* began to land just beyond the little shanty on the left. By the time the first season ended in early November, the little 20-car ferry had transported over 10,000 cars. (Michigan State Archives.)

Three
THE STATE GETS SERIOUS

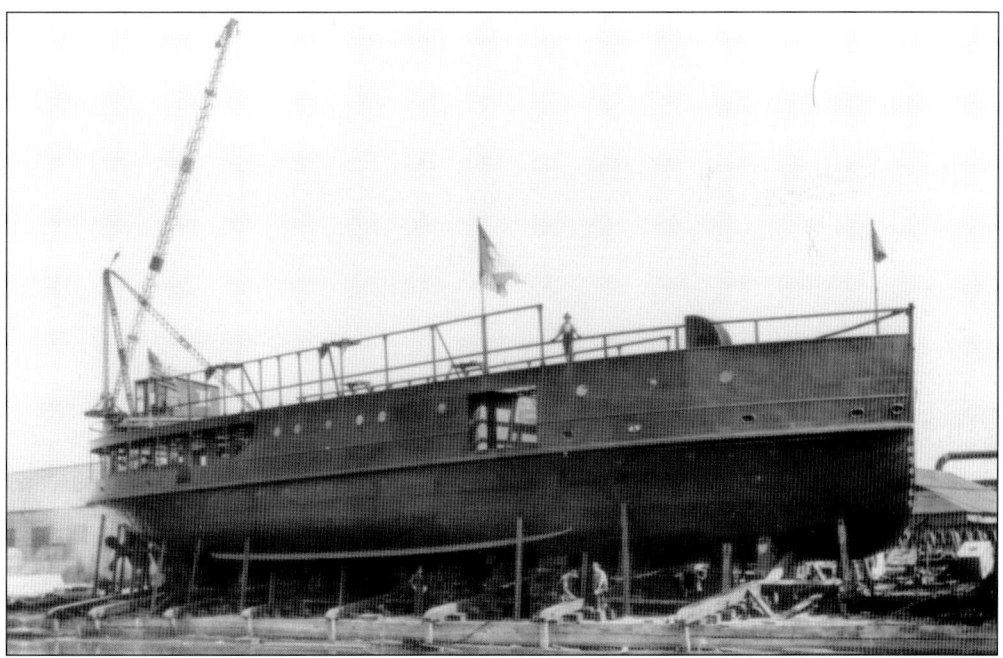

From the start, officials knew the *Ariel* was only temporary. Before she ever sailed, the state considered building a new ship, but instead bought two surplus World War I vessels for $15,000 each. The *Colonel Card* and *Colonel Pond* were junior mine planters built by Fabricated Shipbuilding in Milwaukee, and launched in 1920, too late for the war effort. Although stationed on the East Coast, the ships were brought back to Detroit for conversion to ferryboats. (Milwaukee Public Library, Great Lakes Maritime Collection.)

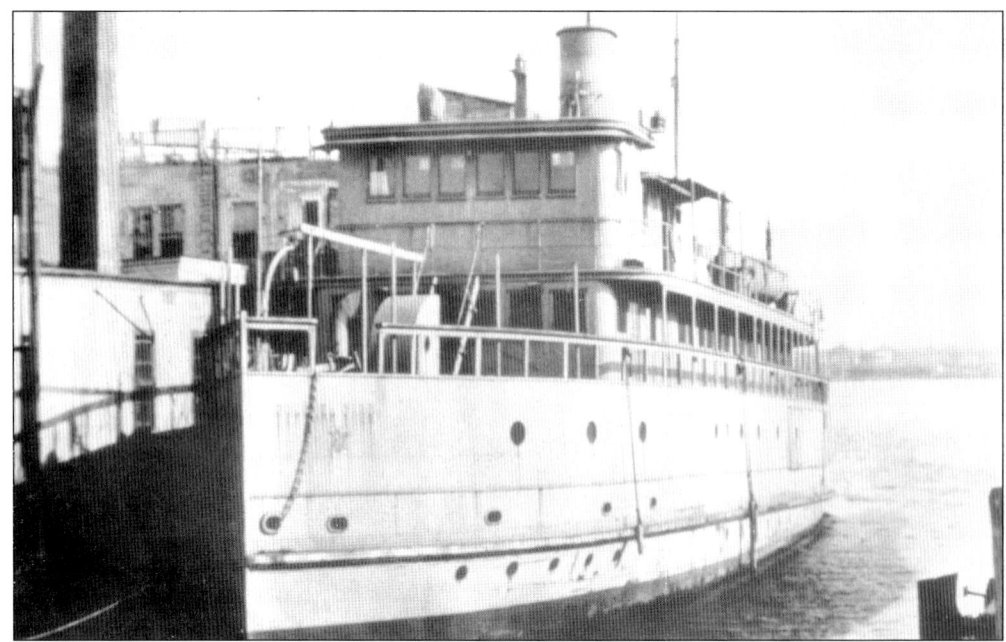

Handpicked Michigan crews were sent to retrieve the vessels. (This is how the *Colonel Pond* looked when they found her in Boston.) The early winter voyage up the St. Lawrence River and across the lower lakes was harrowing and time consuming, as the underpowered ships fought wind, currents, tides and mechanical breakdowns. The trip lasted from Halloween to Christmas Day, when they arrived back in Michigan. (Michigan State Archives.)

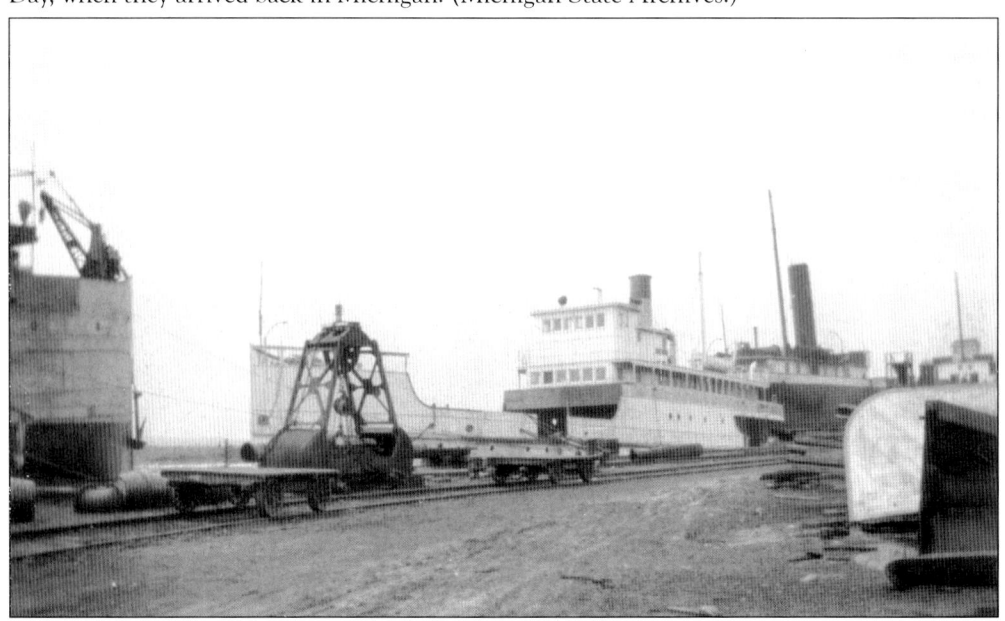

Over the winter of 1923–1924, Great Lakes Engineering Works cut the ships in two, and spliced a 50-foot addition between their bows and superstructures. The lower deck was made into a car deck, and they were renamed the *Mackinaw City* and *Sainte Ignace*. Note the full spelling of "Sainte" in the latter ferry's name, which distinguished her from the earlier railroad boat, the *St. Ignace*. (Author's collection.)

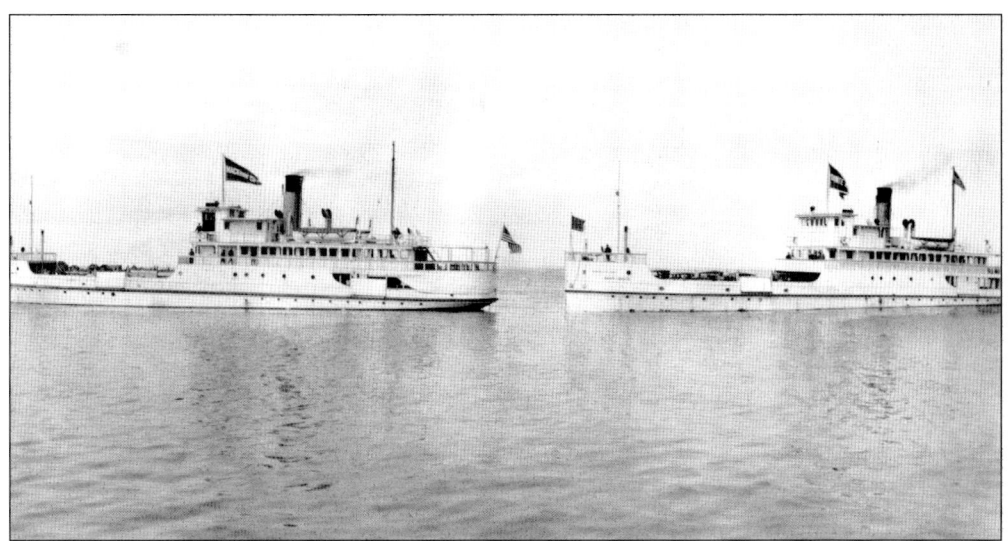

The *Mackinaw City* (left) and *Sainte Ignace* were practically identical. Tarps like the one on the *Mackinaw City*'s stern protected automobiles from spray and waves when the straits got stormy. When the boats reached the straits, C. C. Eby of the St. Ignace Bureau of Information took this photograph with his 360 degree panoramic camera and then made framed prints for distribution to attract visitors. (Author's collection.)

With larger ferries and heavier loads anticipated in 1924, state engineers surveyed the St. Ignace dock over the winter, when they could easily walk underneath on the frozen lake. They recommended strengthening the structure for bigger trucks, and making a slip for the second ferry to land. The old Chambers warehouse was improved as a ferry office and passenger waiting room. (Michigan State Archives.)

Workmen installed a new plank surface on the pier, leading directly from the entryway across to the nearest ferry slip. The "heavy duty" ramp was set up for use under most loading conditions, including heavy trucks and whatever oversized loads could be squeezed aboard. A "light duty" ramp could also be used for automobiles boarding at the other end of the ferry. (Michigan State Archives.)

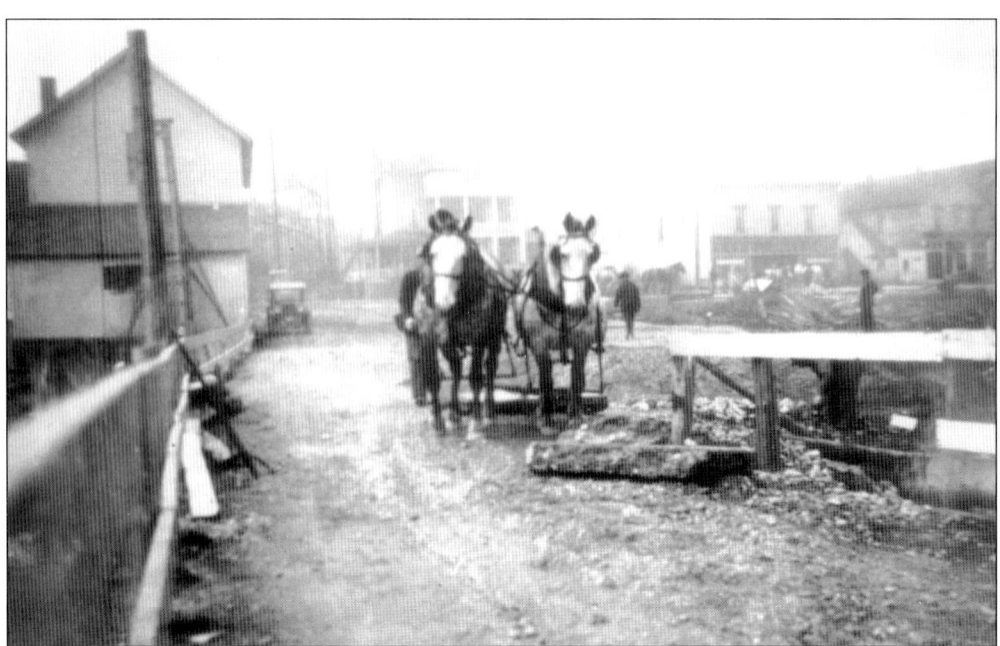

A great deal of fill material was used to level the entryway from State Street out to the pier. Teams of horses pulled scrapers to smooth the driveway, while workers nearer the street cleared debris prior to adding more fill to create a parking area. The St. Ignace newspaper office was just across the street, and reporters kept close tabs on the progress. (Michigan State Archives.)

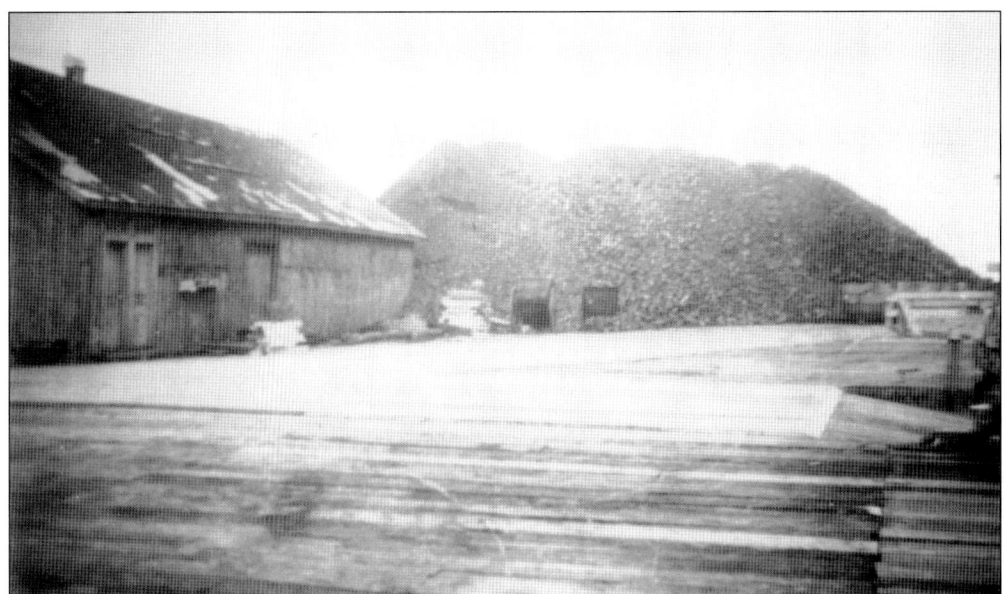

To keep the steamers supplied with coal, workers built a crib at the northeast corner of the dock and had it filled by a collier that landed right at the pier. But the coal usually overflowed onto the dock. Coal passers used scoops, wheelbarrows, and a short conveyer to refill the ferries' bunkers. The ferries were "hand-bombed." Firemen fed the hungry boilers by hand. (Michigan State Archives.)

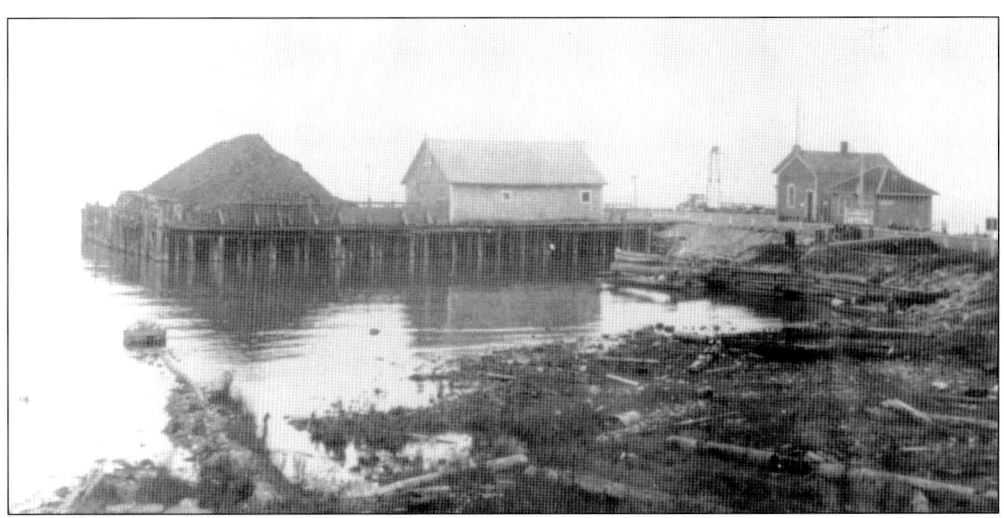

Drivers taking the Michigan State ferry from St. Ignace to the Lower Peninsula saw this as they approached the State Dock in 1924. The photographer was standing on the sidewalk across from the newspaper office on State Street. The logs and flotsam along the shoreline would soon need to be filled in for a larger automobile holding area. (Michigan State Archives.)

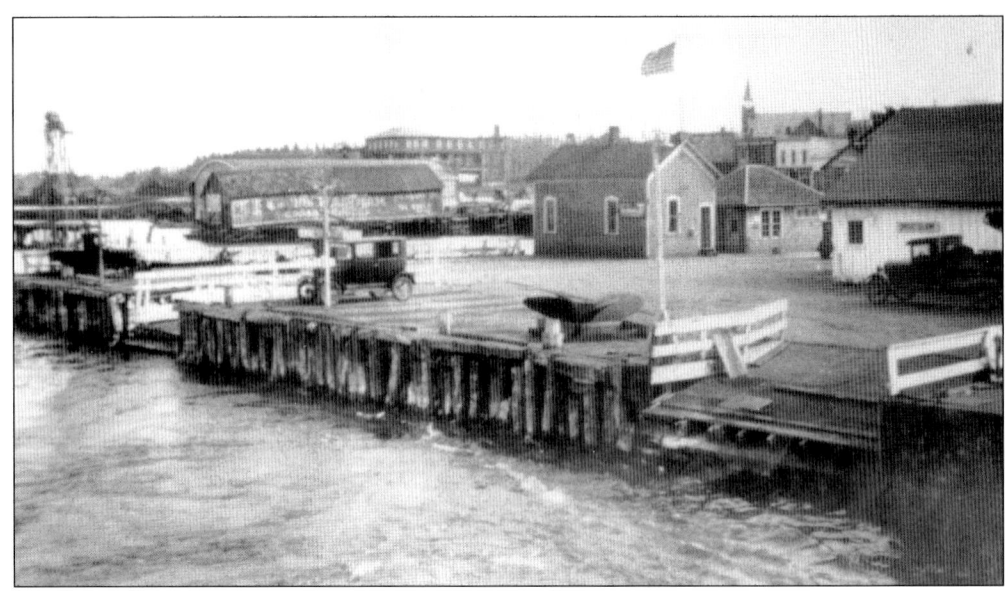
The state continued to clean and improve the State Dock, and by 1925, this is what passengers saw as their ferry approached. This image is looking approximately southwest. The loading ramps to match the ferry gangways can clearly be seen cut into the dock surface, the former warehouse/waiting room has a new roof, and a spare propeller is stored at the ready, should it be needed. (Michigan State Archives.)

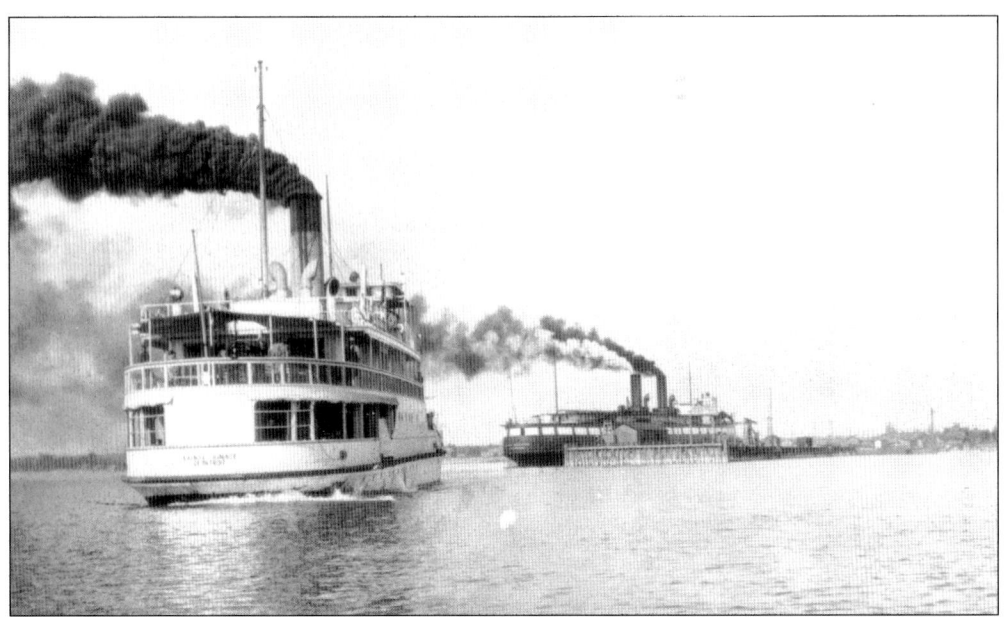
The twin ferries continued to land on the north side of the Railroad Dock in Mackinaw City. The *Sainte Ignace* has just backed away from the landing to the right of the flat pilings, and on right rudder, has rung up "ahead" on the engine room telegraph. The *Chief Wawatam* awaits her next sailing from the railroad apron on the south side of the dock. (Author's collection.)

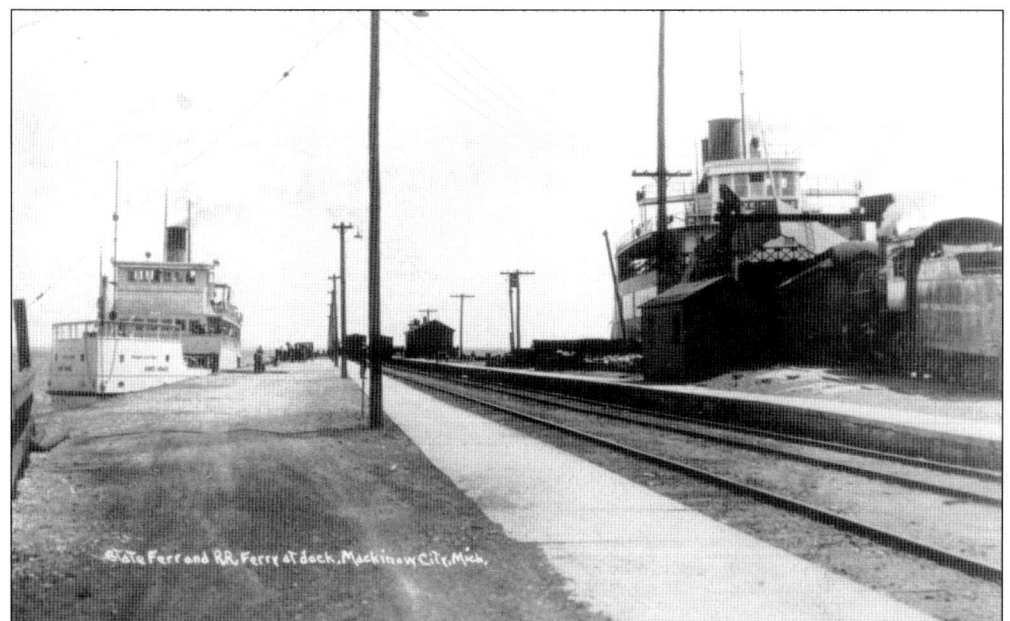

Midday, early in 1924, a late arriving motorist would see this view while scrambling to catch the already-loaded *Sainte Ignace*. A ferry worker stands by the ramp, waiting to guide him aboard. Perhaps the switch engine loading the *Chief Wawatam*'s midday passenger train delayed him, as the access road crossed the tracks just to the right and behind this view. (Author's collection.)

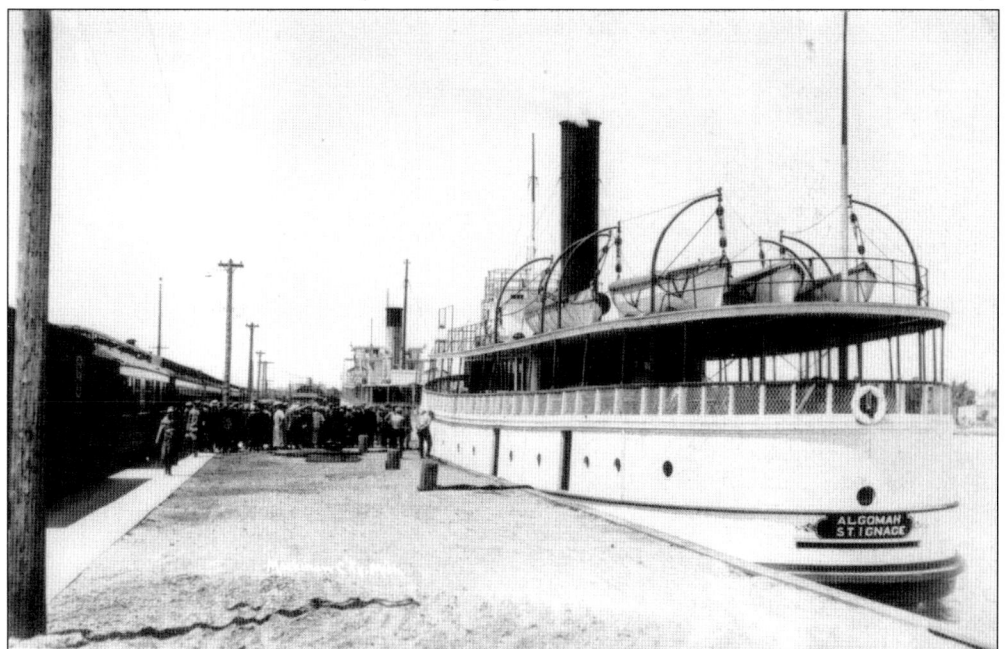

Mackinaw City's Railroad Dock grew particularly congested during resort season, when the *Algomah*, in her new guise as a Mackinac Island passenger ferry, met trains full of vacationers heading to the Grand Hotel or other island resorts. With switch engines, lines of automobiles, and milling passengers, confusion was bound to result. The state ferry is tied in front of the island boat. (Author's collection.)

To solve the problems encountered at the Railroad Dock, for $550 the state purchased some Mackinaw City waterfront just south of there, and hired a contractor to build a 1,409-foot rock-filled causeway to deep water. Hand built rock and mortar guardrails edged the two-lane roadway from just past the tollbooths near the highway, to nearly the end where a single ferry slip was constructed of concrete and wood. (Michigan State Archives.)

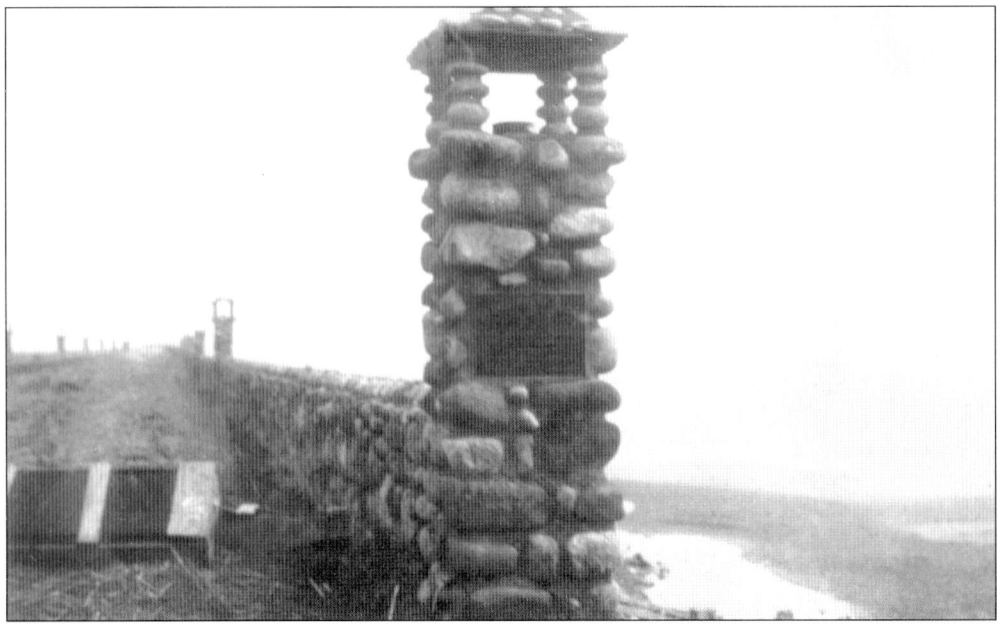
The guardrails were decorated with unique elevated rock towers for electric light fixtures, spaced evenly along both sides of the causeway for nighttime illumination. Each fixture was finished with a round milk-glass globe. The causeway took nearly a year to complete, and for most of 1924, the state boats continued to land at the Railroad Dock in Mackinaw City. (Michigan State Archives.)

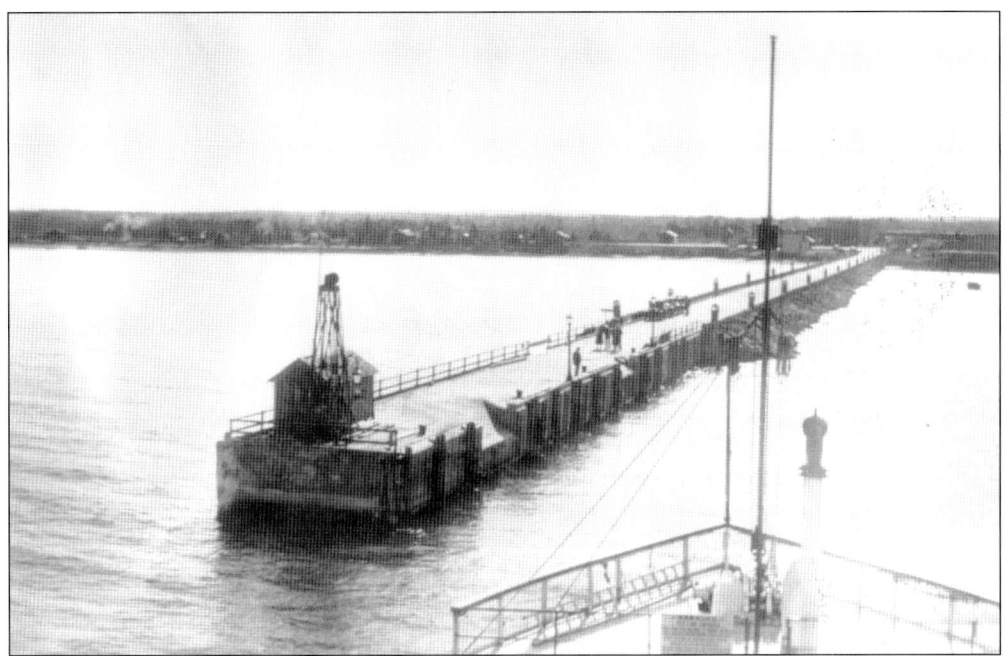

At the new dock, the ferries landed at a single slip, with two ramps, on the north side of the causeway. A one-ramp backup slip was soon constructed on the south side for landings when conditions were too rough to use the north side. The dock was completed with a tower holding a light and fog siren and a small waiting shelter, hauled over from St. Ignace. (Michigan State Archives.)

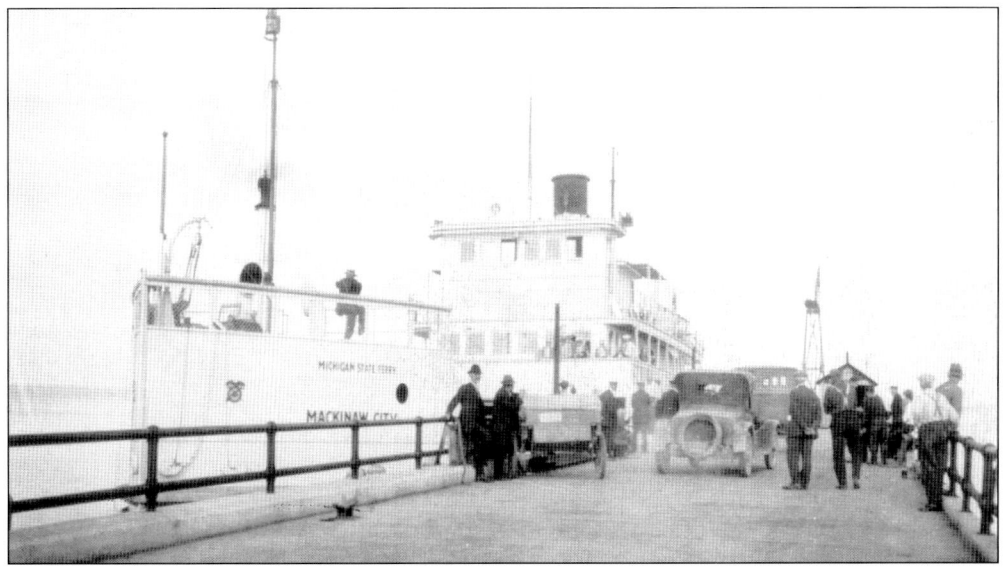

The dock end was narrow and easily congested. Large vehicles had trouble turning onto the ferry. And low lake levels raised fears the causeway might have to be extended even further to reach deep enough water. The *Mackinaw City* is loading automobiles while foot passengers mill about waiting for their turn to board sometime in early 1925. (Author's collection.)

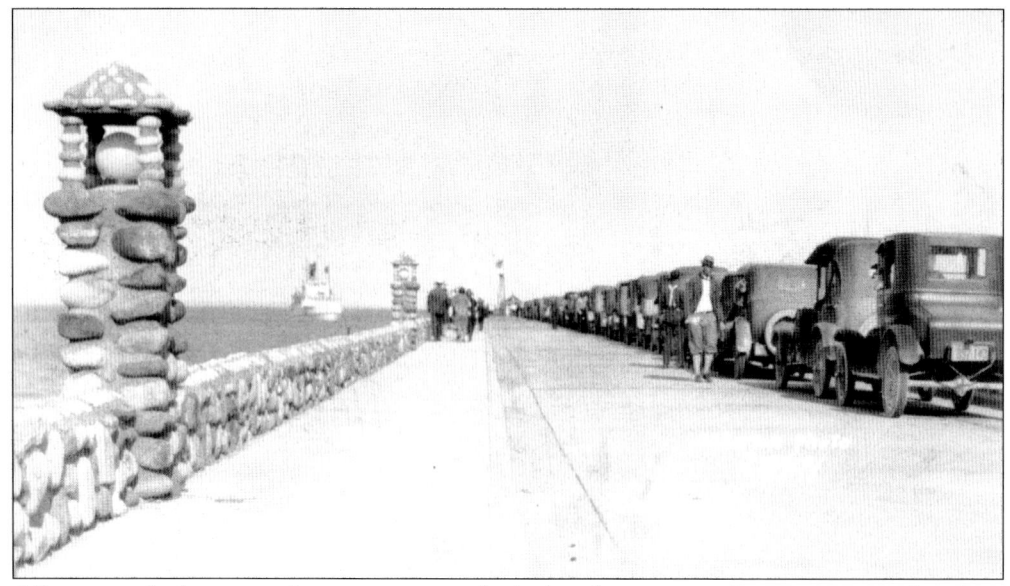

All summer the lines grew longer, as tourists flocked to the region and residents crossed to shop, visit friends, and enjoy entertainment on the other side. The ferries added extra sailings at night, to carry traffic built up during the day, and sometimes still had to direct drivers to the railroad boats if they were going to miss the last trip of the night. (Author's collection.)

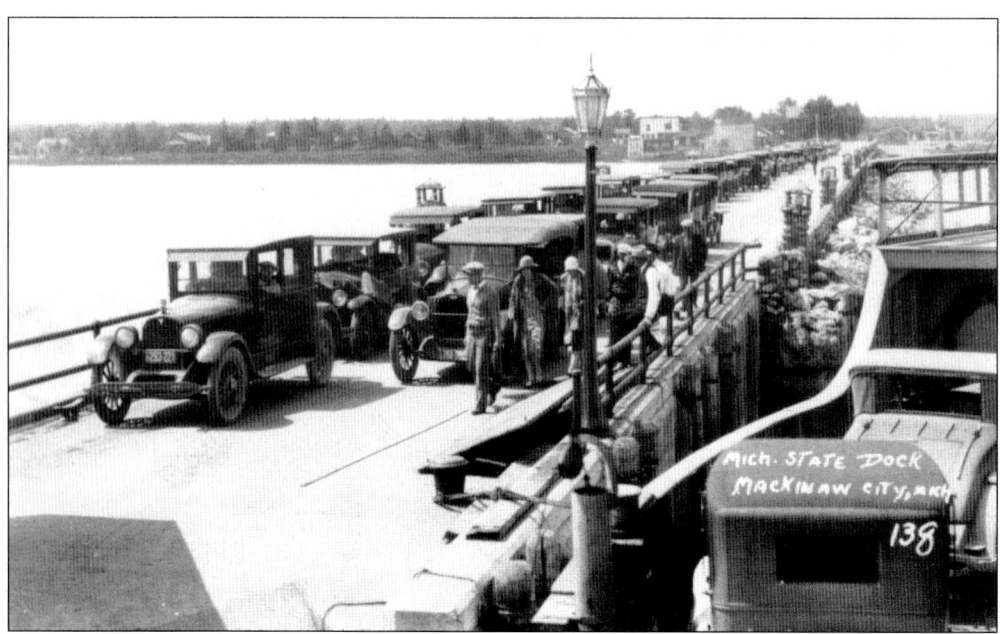

It is the middle of the Roaring Twenties and people waiting for the ferry are dressed in the typical fashions of the era. Perhaps they talked about jazz or flappers—or they were discussing drivers in the left lane who tried to cut in line. Those cars may have to back all the way down the dock, so the boat can be unloaded. (Author's collection.)

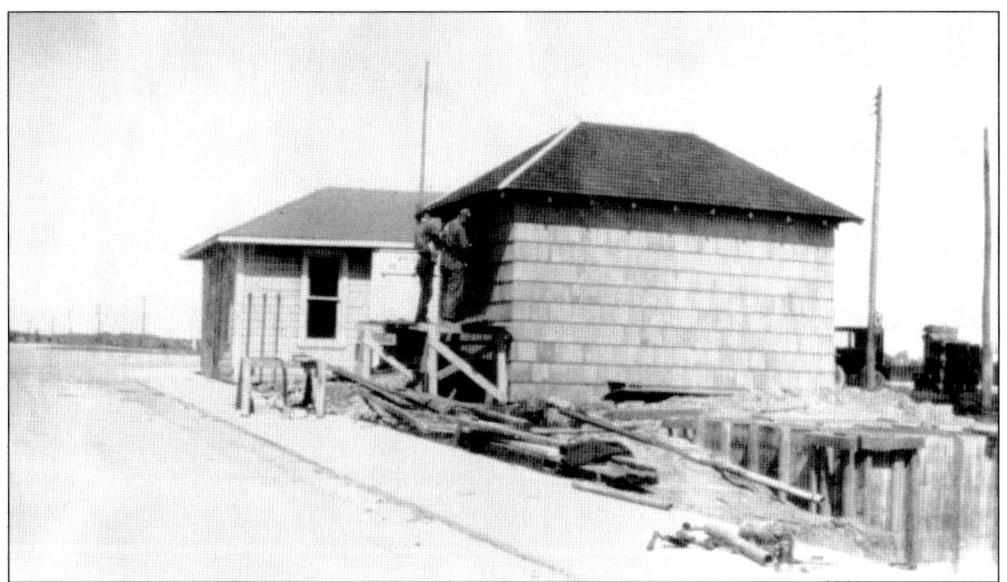

It was a quarter-mile walk from the ferry slip to the comfort stations, which were constructed at the dock entrance back by the highway in Mackinaw City. Imagine waiting in line for hours with a carload of children on a hot August afternoon. Tourists took the waits in stride. They had little other choice. In later years, restaurants and gift shops were built across the street. (Michigan State Archives.)

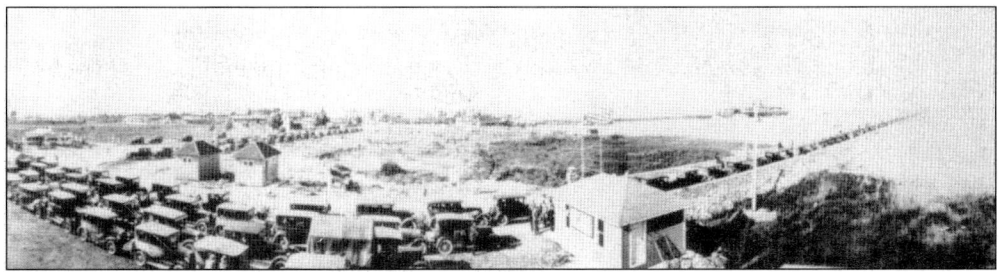

Northbound traffic grew even worse at the start of Michigan's fall deer-hunting season as thousands flocked to the Upper Peninsula woods. Hunting, camping, and spending time in the Upper Peninsula with friends became an annual tradition. C. C. Eby took this view with his panoramic camera and printed postcards sold through his gift shops and other outlets. The *Chief Wawatam* loads in the background. (Author's collection.)

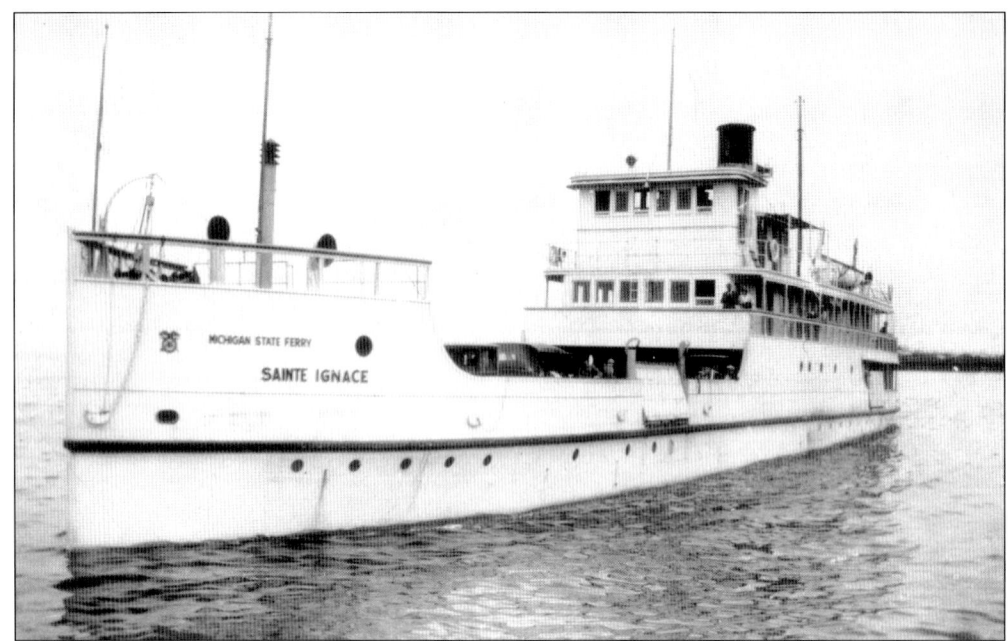

The traffic through the 1925 season was so much greater than expected that a remedy was needed before the 1926 season. Although the *Mackinaw City* and *Sainte Ignace* (shown here) had only been operating as ferries for two years, the fastest solution was to enlarge them. They were taken back to Great Lakes Engineering Works in Detroit for a winter of reconstruction. (Author's collection.)

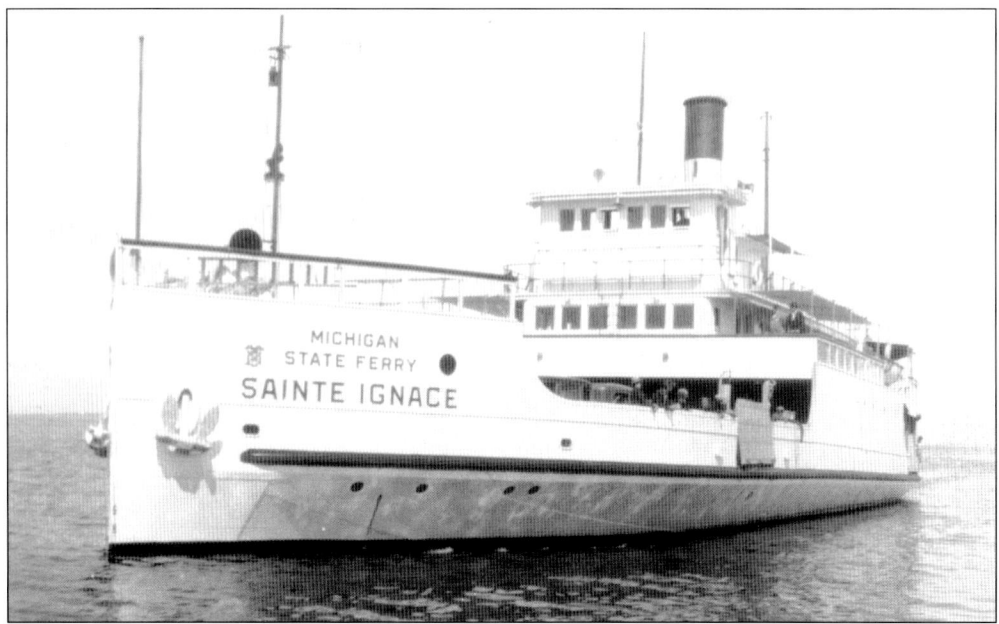

They emerged in the spring of 1926 with hull sponsons making them 8 feet wider on each side. The two additional vehicle lanes gave them almost 50 percent more capacity than before. Although ferry revenues had increased 100 percent in the last year, the state decided to hold off on converting them from coal to oil or diesel propulsion. (Author's collection.)

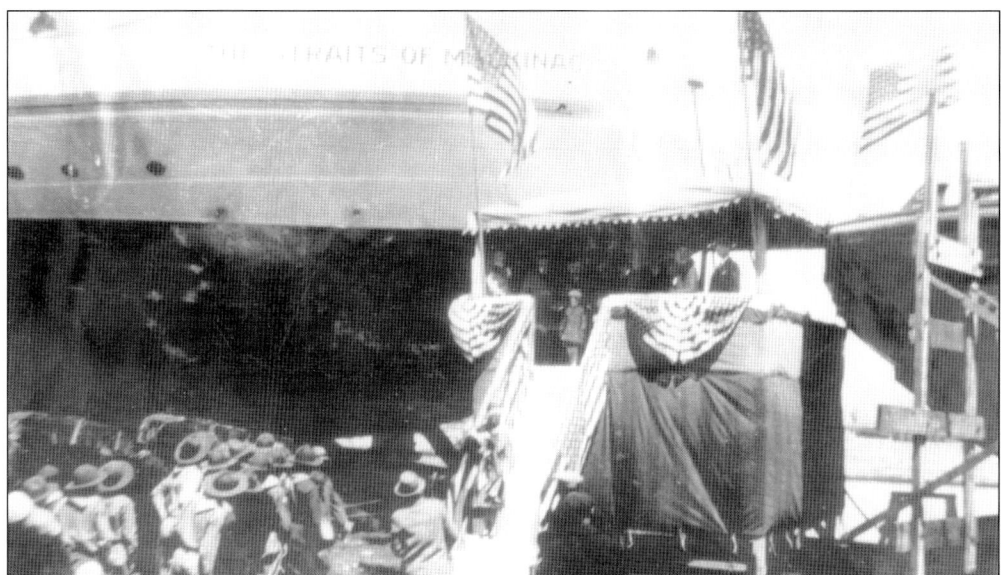

Still traffic across the straits continued to grow. In 1927, Fred Green took over as Michigan's governor, and the Michigan State Administrative Board ordered an entirely new ferry from Great Lakes Engineering Works. She was launched April 28, 1928, and christened by the little girl at the center of the launching platform, Mabel C. Rogers, daughter of the highway commissioner. (Michigan State Archives.)

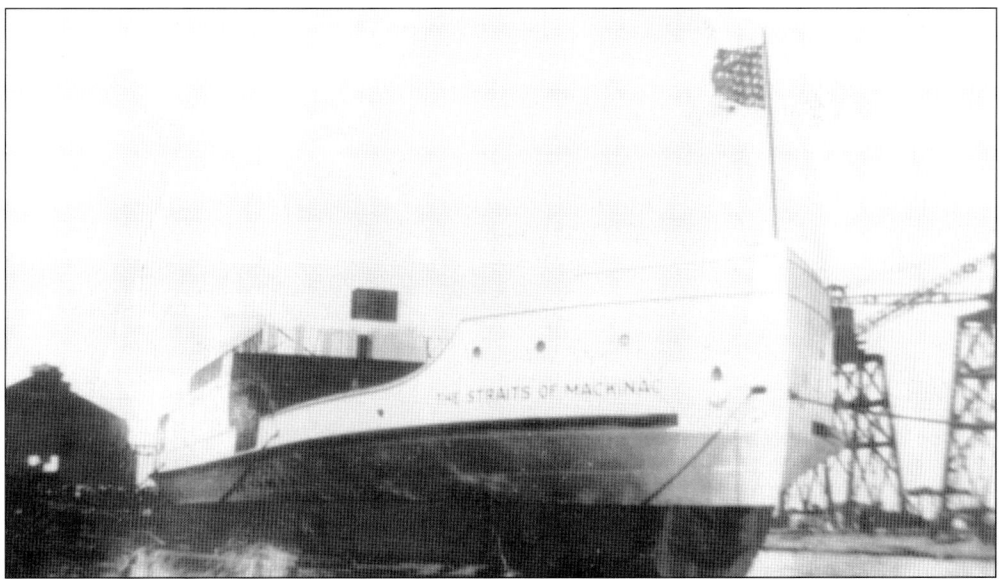

Mabel Rogers is believed to have broken a bottle of water from the straits at the christening, since Prohibition made champagne illegal at the time. She christened the ferry *The Straits of Mackinac;* a name that would forever cause confusion, as most people forgot the article "the" was actually a part of the ferry's name. (Michigan State Archives.)

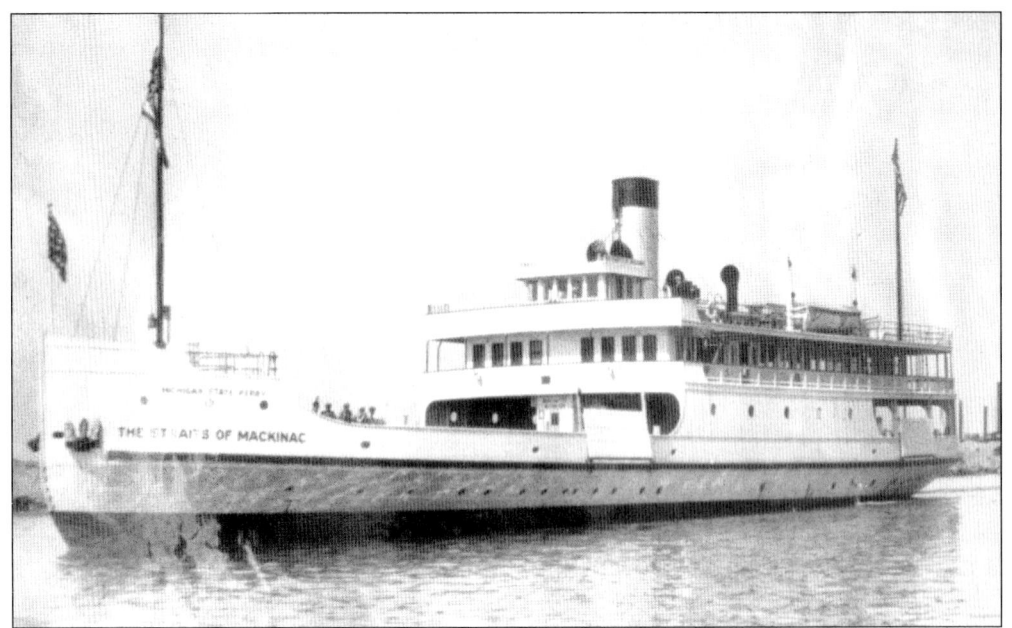

Said to be a cross between a larger version of the two existing ferries and the Detroit River ferry *LaSalle*, *The Straits of Mackinac* was 202 feet long and 50 feet wide. Built to carry 50 cars, she entered service June 20, 1928, giving free rides to anyone who came aboard. This rare but damaged view dates from that era, as she would not last long in this configuration. (Michigan State Archives.)

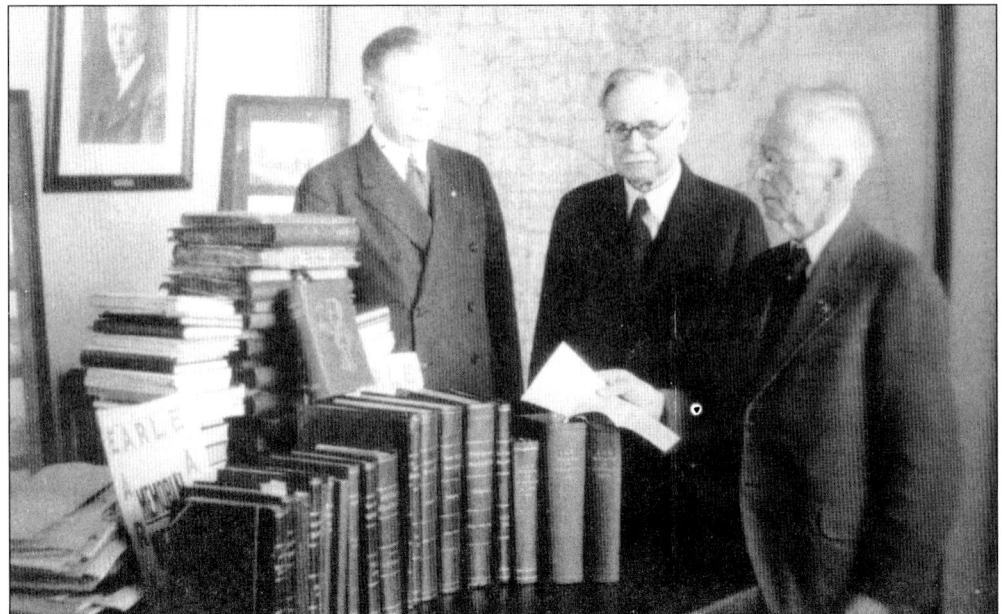

At the end of 1928, Grover Dillman (left) was appointed to succeed highway commissioner Frank Rogers (center), who retired due to ill health. Here they chat in the commissioner's office with former commissioner Horatio S. "Good Roads" Earle. That winter, the state also began subsidizing automobile crossings on the icebreaker ferry *Sainte Marie* (II) at the lower "state" rate for the first time. (Michigan State Archives.)

Four

THROUGH THE DEPRESSION

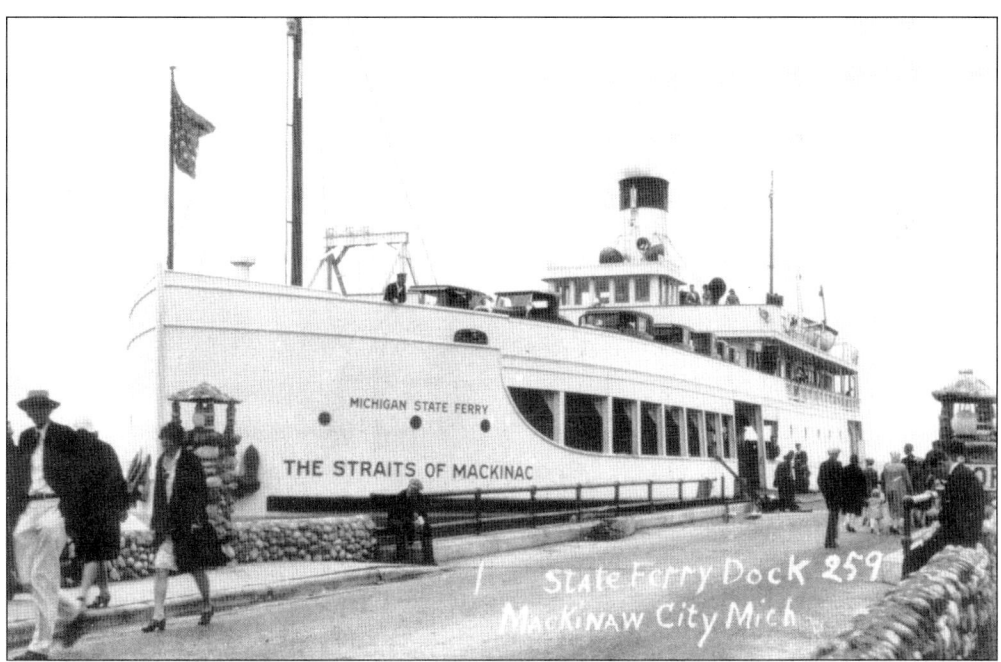

The year 1929 started well enough, with a 33 percent traffic increase over the year before. Over the winter *The Straits of Mackinac* received a new upper automobile deck at the J. B. Lund and Sons shipyard in Cheboygan, increasing her capacity to over 80 cars. Many tourists requested having their cars loaded on the upper deck, to enjoy the view while sitting inside during the crossing. (Author's collection.)

Automobiles accessed the upper deck via a small, one-car elevator mounted near the ship's bow. While the upper deck increased the ship's vehicle capacity, the elevator slowed loading considerably, as the upper deck had to be filled completely, before the front of the lower deck could be loaded. Unloading was similarly impacted. (Author's collection.)

On one Sunday in 1929, the three ferries carried nearly 2,000 cars. This postcard view is titled *An Everyday Lineup* and shows a typical August crush that year at the Mackinaw City terminal. Tourism officials hoped 1930 would be even busier. But it was not to be. In October 1929, the stock market crashed and plunged America into the Great Depression. (Author's collection.)

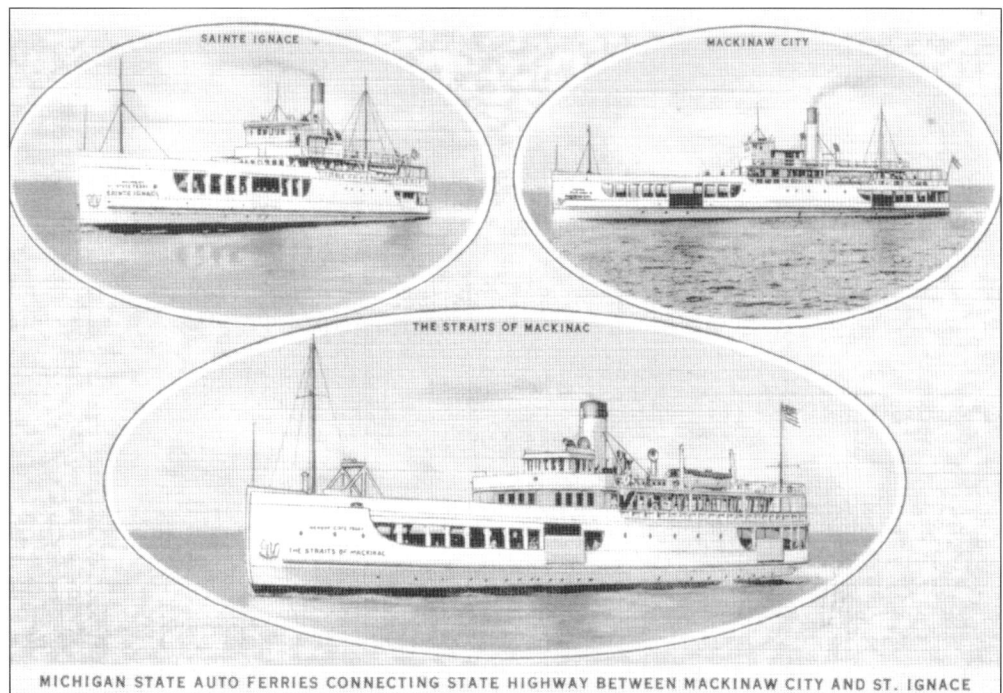

While the impact was not immediate, travelers soon found they needed to economize. Traffic growth at the ferries slowed, and then for the first time, began to decline. To save the state's money, the upper decks were ultimately added to the other boats, but only one per year, beginning in 1930. This C. T. Art/Colortone postcard is by G. H. Wickman. (Author's collection.)

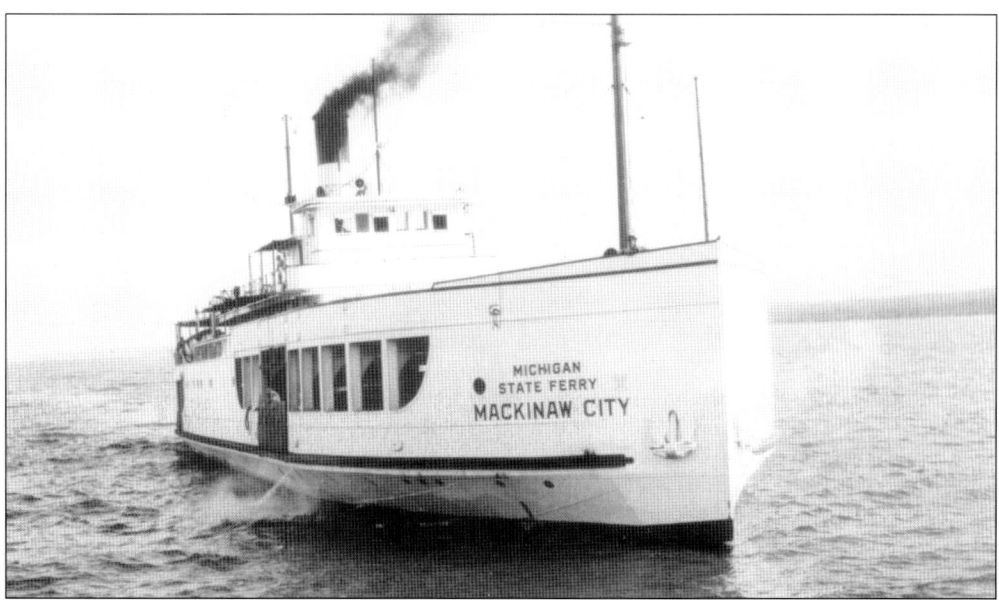

The *Mackinaw City*, with her second deck added, looked like this. Her capacity was nearly 60 automobiles per crossing, meaning the three state ferries could transport 200 cars per cycle, a far cry from the *Ariel*'s 20 cars per trip less than a decade before. The ferries helped mitigate the full effects of the depression for many in the straits area. (Author's collection.)

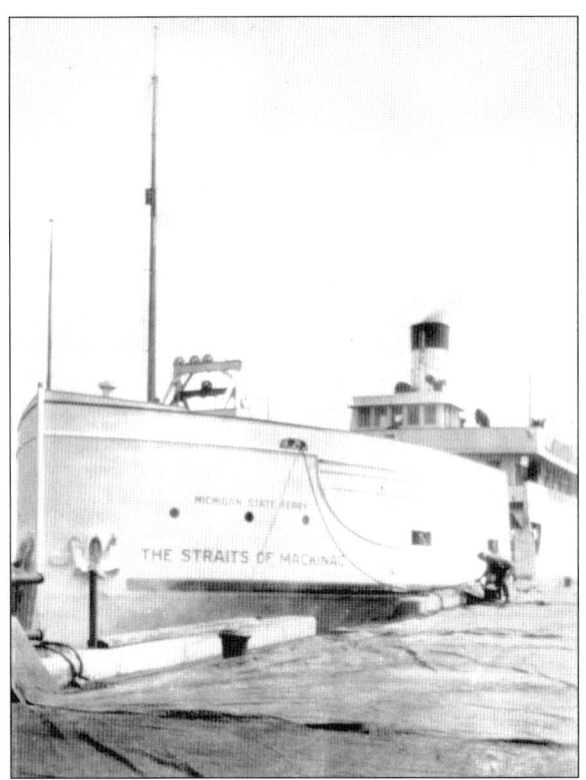

The more powerful *The Straits of Mackinac* tried to extend the season for the state boats, as she could run in moderate ice. The openings in the lower deck could be covered over to protect passengers from cold and wind out on the water. She was also enclosed when laid up for the winter. Why the dock is covered in tarps is unknown. (Author's collection.)

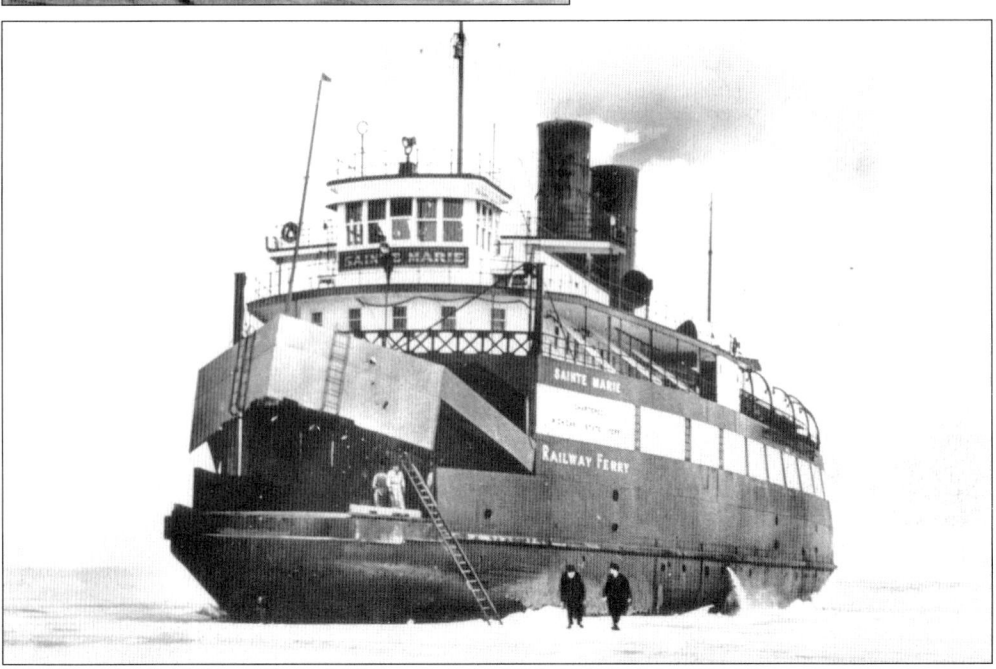

Beginning in the depression, the state chartered the *Sainte Marie* (II) for winter ferry service each year using state crews from the summer boats. But even the powerful icebreaker occasionally ran aground or got stuck. Here the crew has lowered a ladder so passengers could walk to shore, a practice usually discouraged. (Al Hart collection.)

With three ferries in service during the summer, more space for landing was needed. In Mackinaw City, Lyons Construction was hired to extend the causeway with a triangular landing area in deeper water. The work had to be done while at the same time the old ferry slip on the north side of the landing area had to remain in use. (Michigan State Archives.)

For passenger comfort, a new waiting room and restroom building was constructed on the south side of the extension. Passengers would no longer have to hike the length of the causeway to reach a comfort station at the tollbooth. The location of the old north landing slip was indicated on this official highway department photograph with a black wedge. (Michigan State Archives.)

The most pronounced feature of the new extension was the two-story elevator building on the east slip face. By loading upper deck automobiles with a shore based lift, both upper and lower decks could be loaded simultaneously, and the elevators could be removed from the ferries themselves, giving room for two more automobiles. The Mackinaw City tower was built of formed concrete. (Michigan State Archives.)

The finished extension presented a much more attractive view to drivers approaching from the causeway. Still it seemed a long way from the shore, especially in inclement weather, when rain, snow or fog obscured the landing area from the tollbooths, and the elevator seemed to loom above it all. Note the freighter passing on the right side of the photograph. A ferry approaches from the left. (Michigan State Archives.)

This is the view from that ferry. The waiting room is the building in the center of the photograph, while a flag flies from the elevator at the left. The new extension has seen little use, as there are few rub marks on the east slip. The original landing has been removed from the area beyond the dark curve at the far right. (Michigan State Archives.)

In contrast, in 1930, before major renovation, the St. Ignace dock presented this appearance to an arriving ferry passenger. The old warehouse looks completely refinished and sports a sign, "Michigan State Ferry," on the roof. The sign by the door cautions departing motorists to, "Drive Slow." A pair of highway department trucks is parked by the door. (Author's collection.)

The large white building on the right at the dock entrance was the Birchwood Arbor, a restaurant, soda fountain, and nighttime local hangout. From the beginning, tourists found it a convenient place to await the next ferry. It passed through several owners, including tourism promoter C. C. Eby, who sold it just before reconstruction was to start on the St. Ignace landing. (Michigan State Archives.)

The interior was covered almost entirely in birch bark, a design which appealed to Eby, and that he also applied to a number of other locations he owned, including the gift shops at the Indian Village, and at Castle Rock, a rock outcropping north of town that people could climb for a fee, for a spectacular view from the top. (Jack Eby.)

Eby may have foreseen the construction snarl the business (on the right) faced when construction to remodel the St. Ignace ferry dock started. The old house used as an office was torn down, as was the old comfort station behind it. But the dock is still in use. One of the smaller ferries is lining up for a landing by the elevator tower. (Jack Eby.)

Unlike the tower in Mackinaw City, the St. Ignace elevator was built of wood, and lined with metal sheeting. Both towers contained Otis Elevators measuring 10 feet by 30 feet. Each had a 14.5-foot gangway on the water end, and each was capable of lifting 10,000 pounds at the rate of 45 feet a minute. (Michigan State Archives.)

Over the winter, crews prepared the area between the dock and State Street to be filled in. The highway department planned to beautify the entire ferry terminal into a parklike setting, complete with trees, shrubbery, and flowers. It was a bigger job than expected, as large rocks were encountered just below the surface, which had to be blasted away. (Michigan State Archives.)

This view from the top of the elevator shows just how much material had to be removed, relocated, or added to the area. Compare this view with the finished dock, and the location of future walkways, retaining walls, and other features will become more apparent. The rock fill used came from quarries near the St. Ignace airport. (Michigan State Archives.)

After the old warehouse and coal pile had been moved to the ore dock down the street, dedication ceremonies for the new St. Ignace dock were held November 1, 1932. The state opened a new concrete highway all the way from St. Ignace to the Soo at the same time. Businesses all along the route closed so residents could attend the dedication. (Michigan State Archives.)

Since the state had purchased the ore dock, it did not take long to make offers for the Birchwood Arbor and other properties between the two docks. The buildings were torn down or moved, and the vacant land was turned into more parking and holding areas. Since only one slip had an elevator, the north slip was leased to the Arnold Line's island ferries. (Michigan Department of Transportation.)

43

Some motorists were nervous driving onto the upper deck elevators. An attendant guided drivers, telling them when to stop. The tops of the lifts were open, and passengers could see the sides of the tower through their windows as the platform went up or down. The height of the lift could be adjusted, depending on water levels or how laden the ferries were. (Michigan State Archives.)

Drivers leaving the upper automobile deck would see this rare view inside the elevator. Once inside, the gangplank was raised, the lift was lowered, and then the louvered door ahead was opened, so the car could drive out onto the dock. Only one car could be raised or lowered at a time, and it was a slow process to load and unload the boat. (Michigan State Archives.)

Five

THE FERRIES GROW UP

Fed up with the Depression, voters turned away the longtime Republican office-holders, and voted Democratic in Michigan. On July 1, 1933, Murray Van Wagoner took over as head of the Michigan State Highway Department and immediately fired one ferry captain. Many of the captain's crew walked off with him, tying up the boat for one trip on the busy Fourth of July weekend until a new crew could be hired. It was the first labor action in state ferry history. (Bentley Library, Van Wagoner papers.)

Feeling they had connections in the nation's capital, Michigan Democrats began a push to get money to bridge the straits, saying government "back to work" programs would benefit by employing hundreds to build it. Michigan's Washington delegation got strong interest, but no firm commitments, while ferry traffic once again began to build. (Michigan State Archives.)

During 1933, tourists began to return to the ferries, and over Labor Day, the ships carried 1,500 more vehicles than they had the year before, a sign the worst of the Depression might be over. During hunting season, the ferries abandoned their printed schedule and "ran wild" to accommodate all the traffic wanting to cross. Meanwhile, the Democrats appointed a Mackinac Bridge Authority. (Michigan State Archives.)

Once again traffic was reaching record proportions on the ferries, but even if the money was found, it would take years to bridge the straits or build a new boat, and help was needed now. Murray Van Wagoner turned to the used-boat market and bought a Lake Michigan car ferry from the Ann Arbor Railroad. The *Ann Arbor No. 4* was originally constructed in Cleveland in 1906. (Al Hart collection.)

The 259-foot ship must have held the record for car ferry accidents. In 1909, a switching crew put an entire cut of iron ore hoppers onto an outboard track, without balancing the other side. She slowly capsized at her slip in Manistique. In the 10 minutes it took to completely go over, her crew escaped uninjured. Righting her took much longer. (Daisy Butler, Arthur Fredrickson collection.)

The *Ann Arbor No. 4*'s worst fiasco was in February 1923. On a calm night, a severe storm hit unexpectedly, causing her cargo of freight cars to come loose, smashing stanchions, steam pipes, and tearing out her stern seagate. In a heroic effort, her crew made it back to the entrance of their home port, but the ferry struck the jetty and sank in the channel. (Daisy Butler, Arthur Fredrickson collection.)

Incredibly, everyone escaped by climbing down a ladder to the jetty, and they made it home safely that night. The *Ann Arbor No. 4* remained frozen in the channel for the winter, sunk to above her car deck, and with nearly half of her superstructure torn loose from the pounding she took. (Daisy Butler, Arthur Fredrickson collection.)

She was ultimately raised the next spring and towed off to Manitowoc Shipyard for a complete rebuilding that lasted nearly 5 months. A nearly new ship emerged, with new cabins, a pilothouse a deck higher than her old one, and rehabilitated engines. Although that was her worst accident, her luck with the railroad did not change, and they were glad to sell her. (Daisy Butler, Arthur Fredrickson collection.)

For the conversion, Michigan took her first to Manitowoc, and then to Lund's shipyard on the Cheboygan River. Her tracks were removed, side-loading doors with ramps were cut into her sides, and she was painted white. Commissioner Murray Van Wagoner announced she would be renamed *City of Cheboygan* for the community so close to the straits: "it deserves the honor!" The detail seen here is from an L. L. Cook postcard. (Author's collection.)

49

After a number of delays, days when continually building traffic at the straits could have really used her, the *City of Cheboygan* was finally ready for christening on August 4, 1937. A huge crowd gathered in her namesake city to watch the event, hosted by Col. Roger M. Andrews, chairman of the Mackinac Island State Park Commission, and sponsored by the Cheboygan Chamber of Commerce. (Michigan Department of Transportation.)

The highway commissioner and his daughters, seven-year-old Ellen and nine-year-old Joan Van Wagoner, rode through town to the christening in a horse-drawn wagon, and after the appropriate remarks, Ellen swung the bottle of champagne to christen the ship, while her proud, white-clad father, "Admiral" Murray Van Wagoner, looked on from behind her. (Michigan Department of Transportation.)

With flags flying and smoke billowing, the *City of Cheboygan* then sailed off on a VIP tour from the mouth of the Cheboygan River, around Mackinac Island, and back. Commissioner Van Wagoner then left for New York to confer with designers of a possible new diesel icebreaking ferry, while the *City of Cheboygan* was taken to St. Ignace, to go into service the next day. (Michigan Department of Transportation.)

The *City of Cheboygan*'s car deck seemed huge compared to the other ferries in the fleet. The former railroad boat could swallow up to 96 cars per crossing. Her capacity was much appreciated, as in the month of July the ferries had carried 28 percent more cars than in the same month the year before. In her first day of service, the *City of Cheboygan* alone moved over 500 cars. (Michigan Department of Transportation.)

51

Engineers carefully measured the distance between the dock's loading ramps, and her side gangways were cut to match, so the *City of Cheboygan* had no trouble loading from her sides like the other ferries. But as on the others, motorists had trouble making the turns around the ship so the entire car deck could be filled. Trucks had to back on or off. (C. C. Eby Company.)

Officials eyed her square stern and toured ferry lines that end-loaded automobiles to find if they could save much time that way. They learned most automobile ferries were end loaders, except those operating on rivers with strong currents. The straits operation had been originally designed for the *Ariel*, a Detroit River ferry! They also learned keeping a coal burning ferry white was a continuing problem. (Author's collection.)

An unknown tourist took this photograph, dated July 3, 1937. It was taken a month before the *City of Cheboygan* entered service. It is fuzzy and out of focus, but it illustrates the problem the highway department faced in moving traffic. The State Dock in Mackinaw City can be seen far in the background. Beyond it, the *Chief Wawatam* is also loading automobiles, as she was chartered to help for the day. (Author's collection.)

While shoulder seasons were not as busy, like here in St. Ignace, by July each year traffic was backing up onto the main highways regularly. Motorists no longer boarded the next sailing, or the second. Some waited all day to cross on busy weekends and holidays. Capacity was again needed quickly, and when bids for a new boat were "excessive," Murray Van Wagoner bought another used one. (Michigan Department of Transportation.)

The *Pere Marquette 20* was one of two 338-foot-by-56-foot car ferries built in 1903 for service across Lake Michigan out of Ludington. The *Pere Marquette 20* was built in Cleveland, and like her twin, was designed as a freight boat, with few passenger cabins. She had been laid up since the Depression, since the freight business had not yet fully recovered. (Al Hart collection.)

It took $25,000 in emergency repairs before she could even leave for a shipyard. Her state ferries crew spent days cleaning out parts stored in her cabins, and scraping off droppings from birds nesting above her car deck. Finally she was fired up and sailed directly to the shipyard in Manitowoc. She was a sorry sight when she arrived, as this shipyard picture shows. (Michigan State Archives.)

Upon arrival she was dry-docked for a complete inspection. Her stern tubes were pulled, her bearings replaced, and yard engineers made a complete rehabilitation of her triple expansion engines and auxiliaries. Her boilers were considered too old, so they were replaced with a nearly new set taken out of the *Pere Marquette 15*. The rails were removed from her car deck. (Michigan State Archives.)

The yard also completely inspected her 12-foot-diameter propellers. These "screws" had four individual bronze blades bolted to a steel center hub. That way, if a blade was broken, it could be replaced without having to change the whole propeller. It was a job the railroads often did just by ballasting the ship down in the front to raise the blade out of the water. (Michigan State Archives.)

The *Pere Marquette 20*'s pilothouse and complete superstructure were removed to make way for new steel crew quarters and passenger lounges on the spar deck, and a more modern steel navigation bridge with docking wings above. A layer of cement was spread on her car deck where the rails had been to make a more suitable driving surface and to add ballast. (Michigan State Archives.)

Engineers asked someone back at the straits to measure the side openings on the *City of Cheboygan*, because nobody had brought any plans along. Openings were cut to match, so the new ferry would line up for side loading like the other ships. New funnels were fabricated and installed. They would be painted silver and black before she entered service. (Michigan State Archives.)

Since the entire superstructure was new, designers took care to make a small, but pleasant passenger waiting lounge. The state ferries never had food service for passengers onboard, as the crossing only took about 40 minutes. But people did want a comfortable, warm place to sit on cold, rainy, or even snowy days. The finished lounge would be fitted with chairs and light bulbs. (Michigan State Archives.)

Almost as fast as the steel superstructure was erected, scaffolding was raised so the ship could receive primer and a coat of gleaming white paint, to match her new sisters at the straits. At the end of May, the Michigan State Administrative Board announced she would be named *City of Munising*, after the Upper Peninsula city, a name meaning "safe harbor." (Michigan State Archives.)

Only days before her scheduled christening, the newly designated City of Munising posed for portraits as finishing touches were added at the shipyard. This view was made into some of the earliest postcards sold at the straits—cards released before the ship had even left the shipyard. Of course, the artwork was heavily retouched to remove the scaffolding from along her side. (Michigan State Archives.)

Here is an artist's rendition, based on the photograph above, which was released by the highway department to show what their new ferry was going to look like. A bow wave has been added, but there are very few details like wires, lines, or even a visor over the pilothouse windows. (Michigan State Archives.)

58

G. C. Wickman, who published a number of postcards through the Curteich Publishing Company, issued this view of the *City of Munising*, which was used in one form or another, both in color and black and white, for the rest of the decade. It is based on the previous postcard, but has the missing details drawn in, including ship's flags and a steering pole. (Author's collection.)

Finally, this is what the *City of Munising* actually looked like as a tug towed her out of Manitiwoc Shipbuilding on Sunday morning, June 25, 1938. She spent her first night in Menominee and then sailed to Escanaba for the official christening with invited guests driving down from her namesake city. Officials thought it was too far to go all the way to Munising with the ferry. (Author's collection.)

The trip to Menominee included a number of special guests invited to ride her shakedown cruise. The VIPs gathered on the fantail for a portrait as the ship left Manitowoc harbor and headed out into Lake Michigan for the first time under her new registration. The little room with windows behind them is the after wheelhouse, used when backing into a landing slip. (Michigan State Archives.)

At Menominee, huge crowds turned out to welcome the ship. A radio broadcast was scheduled to carry the christening live from Escanaba on WJR, but it had to be simulated, when the highway department's planners ordered time on the network but forgot to allow for the change to daylight time. Mrs. John W. Hanna, wife of Munising's mayor, finally christened the ship. (Author's collection.)

When she first arrived, the *City of Munising* used her side ramps like the *Cheboygan* and smaller ferries before her. Here she is tied up in St. Ignace having just unloaded from one of her earliest crossings. But that was about to change, thanks to plans the state had put into motion while she was still at the shipyard. (Michigan Department of Transportation.)

Just to the left, and above the church steeple, the Chambers Dock is visible in this 1909 St. Ignace postcard view. The large black pier to its right is the ore dock, originally used in an attempt to capture some of the bulk iron ore business coming from Lake Superior. The state bought it and made it into a coal dock for the ferries. (Author's collection.)

Soon after the new ferry was purchased, the state began converting the coal dock into an end-loading pier for the two former rail ferries. A slip to match the ferries' square sterns, left over from railroad days, was constructed, along with automobile loading aprons and a new vehicle holding area on a long pier to deeper water. (Michigan State Archives.)

Located between the State Dock and the Railroad Dock, the coal dock nears completion in its new guise as State Dock No. 2. One of the smaller ferries has landed there to take on coal, while the *City of Cheboygan* rests at the newly designated State Dock No. 1. The *Sainte Marie* (II) is at the Railroad Dock, with the *Chief Wawatam* at the merchandise dock, beyond. (Michigan Department of Transportation.)

Here is another aerial view of St. Ignace, with all three of the smaller ferries in sight. *The Straits of Mackinac* heads for a landing at State Dock No. 1, as one of the smaller ships is leaving. Under a cloud of coal smoke, the third ferry takes on fuel at State Dock No. 2. A passenger ferry to Mackinac Island is backing from the north slip at State Dock No. 1. (Michigan Department of Transportation.)

From the ground, new State Dock No. 2 looked like this. The newly arrived *City of Munising* has backed into the end loading slip while across the pier, one of the older twins takes on coal. There are not yet any tire tracks in the gravel holding area at the bottom of the picture. In the future this would be full of traffic. (Michigan Department of Transportation.)

In another view from the air, the coal pile is easily visible between the walls of State Dock No. 2. Traffic has begun to use the new facility, as the *City of Munising* takes on a load of automobiles from the line that curls around the gravel holding area and out onto State Street. There are no automobiles waiting for the ferry on State Dock No. 1, at the far right. (Michigan Department of Transportation.)

In Mackinaw City, contractors began a major expansion of the ferry terminal. Dredge spoils from Lake Huron were used to fill a 200-foot-wide holding area to the south of the rock causeway. This was outlined with heavy stones hauled in by dump truck to keep the spoils in place. At the north slip, the *City of Munising* takes on another capacity load of 115 cars. (Michigan Department of Transportation.)

A long wing extended out from the edge of the fill, and an apron and hydraulic lift structure were mounted on cribs where the ships would land, just south of the existing south side loading slip. The long paved wing gave plenty of room for dockhands to handle lines when the ferries came in to land. This is an L. L. Cook postcard. (Author's collection.)

The new Mackinaw City dock provided acres of holding area designed to keep waiting cars off the state highways leading to the terminal when traffic backed up. The flagpole in the center of the picture was mounted on the end of the wing extending from the end-loading slip. *The Straits of Mackinac* is at the east slip, taking on a load of cars at the elevator. (Author's collection.)

The size of the holding area is apparent from the air. *The Straits of Mackinac* and the two smaller ferries normally landed at the elevator and left the south slip open to give more room for the big ferries to land, although all four slips could be used at the same time if that many boats were on the same side. The Railroad Dock is to the right. (Michigan Department of Transportation.)

The *City of Munising* put on a show backing into the end-loading slip south of the waiting room and elevator tower. Many tourists from outside the area had little experience with big ferries, and the opportunity to watch the white ships come and go proved irresistible under blue skies on a warm sunny day. There was usually a breeze at the end of the dock. (Author's collection.)

End loading sped up the ferries' turnaround time, as cars only had to make one turn onboard the boat. Automobiles drove up one side of the car deck, turned around at the bow, and then drove back down the other. Some large trucks still had to back on or off, but many of their drivers were frequent riders and so had experience with the move. (Author's collection.)

Almost the whole expanse of Mackinaw City's State Dock could be photographed from the top of the elevator tower. When it first opened, streetlights illuminated only the center roadway on the big filled parking lot. Later they were moved to the edges when the whole area was paved. The material on the edge of the tower was to discourage seagulls from roosting there. (Bentley Library, Ziegler papers.)

In 16 years, the state ferries had not had a serious accident involving passengers. That changed June 8, 1939, soon after the end loading slips went into service. In a thick fog, the northbound *City of Cheboygan* smashed almost broadside into the southbound *Sainte Ignace* traveling on the opposite heading. The smaller ferry was heavily damaged, but fortunately all above the waterline. (St. Ignace News.)

The collision ripped a 20-foot hole in the *Sainte Ignace*'s side, while collapsing two upper-deck beams onto the occupied cars below. Eight people were injured; some with broken bones, others with cuts and bruises. The ship's cook was scalded when hot soup spilled on him in the galley. Passengers were ordered to don life vests as a precaution. (St. Ignace News.)

Fortunately the sponsons installed when the *Sainte Ignace* was widened absorbed most of the impact. No one was injured on the *City of Cheboygan*. Her damage consisted of heavy scrapes, and a 6-inch hole punctured well above the car deck by a deck beam. While it cost $10,000 to repair the smaller ferry in Lund's shipyard, the *City of Cheboygan* was repainted and back on the run that afternoon. (St. Ignace News.)

Despite the accident, traffic on the ferries continued to set records all summer. On the Sunday before Labor Day, 1939, the ferries carried 4,236 vehicles, a new all-time record. Hunting season saw the ferries handle almost 21,000 cars. Note some of these northbound vehicles have dust on the sides. Not all roads to Mackinaw City were paved. (Michigan Department of Transportation.)

69

In 1939, to speed ferry travel between the peninsulas, the highway department began construction of a new causeway southward from Pointe LeBarbe, the closest point to Mackinaw City on the Upper Peninsula. The idea was to put a ferry slip at the end, shortening the route for now, and later use it for the beginning of the long awaited bridge across the straits. (Michigan Department of Transportation.)

By the time World War II began, the causeway extended nearly a mile out into the straits, lined with heavy boulders to prevent wave action from causing erosion. But the war put a temporary halt to the effort, and the ferries continued to use State Docks No. 1 and No. 2 downtown. The buildup for the war meant even bigger changes were on the horizon, however. (Michigan Department of Transportation.)

A study showed that replacing the two smallest ferries with one larger one of the same capacity would save $20,000 a year in operating costs. So when the federal government asked to reacquire them in the fall of 1940, the highway department jumped at the chance to sell the vessels. The war department bought them in October for $75,000 each. Michigan had originally paid $15,000. (C. H. Truscott collection.)

That meant the ferry service needed another ship fast, in time for the November hunting season. The ship they purchased was the *Pere Marquette 17*, a 1901 product of American Shipbuidling's Cleveland yard. Identical in size to the *City of Munising*, she was hurriedly painted white and pressed into service under her original name. This is a J. E. McCourt postcard. (Author's collection.)

Like most other car ferries, the *Pere Marquette 17* had her share of mishaps, but her greatest claim to fame was her effort to assist the *Pere Marquette 18* (I) when she foundered September 9, 1910, with the loss of as many as 29 crew members. The *Pere Marquette 17* lost two of her own, but managed to rescue 35 souls, who would have been lost without her. The detail seen here is from an F. W. Andrews postcard. (Author's collection.)

Noted marine architect Robert Logan designed the *Pere Marquette 17*, the first ferry bought new by the Pere Marquette Railroad, shown here on her delivery voyage. Unlike the *Pere Marquette 20*, the *Pere Marquette 17* had a single passenger cabin on her upper deck. Although she had been repainted before arriving, observers felt she would need a lot more work, so that winter she was taken to River Rouge. (Author's collection.)

There was another departure before 1940 ended. Murray Van Wagoner had run for Michigan's governorship, and he won. So the highway department came under control of his assistant, G. Donald Kennedy, and Van Wagoner became governor at the beginning of 1941. One of Kennedy's first challenges was a ferry vote to unionize. While it did not pass this time, there would be more in the future. (Michigan Department of Transportation.)

Kennedy also had the pleasure of presiding over the dedication when the remodeled *Pere Marquette 17* was renamed *City of Petoskey*, for the community on Little Traverse Bay. Governor Van Wagoner's daughter Joan did the christening honors, May 25, 1941, on the breakwater off the ship's new namesake city. The ship then hosted a public reception across the bay in Harbor Springs. This is an L. L. Cook postcard. (Author's collection.)

Although not as extensively remodeled as the *City of Munising*, the finished *City of Petoskey* looked very similar. Only one side-loading gangway had been cut into her sides however, as the state now was using the end loading ramps almost exclusively for all but *The Straits of Mackinac*. The public was invited to sail back with her to the straits, so long as there was room. (Bentley Library, Kennedy Collection.)

The new ferry became a hit with tourists, and local outlets were quick to capitalize on her popularity, issuing all manner of souvenirs bearing her image. A tourist snapped this view of her while on vacation on July 7, 1941, just after the Independence Day holiday rush when 28 percent more cars crossed than the year before and even the rail boats were pressed into service. (Author's collection.)

To try to keep up with the lines of cars streaming onto the docks, the ferries ran wild all night, only getting less than full loads in the very early morning hours. Here the *City of Petoskey* backs into Mackinaw City with only about half of her normal 115-car load. The captain in the window of the after wheelhouse is controlling the landing. (Michigan Department of Transportation.)

Day or night, crews did their best to be friendly and helpful while keeping the traffic moving. While not directly engaging in their duties, they often answered tourists' questions about nearby accommodations, attractions, and travel directions. Crew members often lived aboard in the prewar era, so they had many opportunities to mingle with the passengers. (Author's collection.)

The first ferry worker motorists encountered was the ticket seller, cashier, or purser, who counted the passengers in the car, and charged the appropriate fare. Drivers were then directed into a waiting lane for their turn to board the ferry. Traffic directors checked their receipt before boarding, and then helped guide the lanes onto the boat when the time came, and deckhands directed the traffic onboard. (Michigan Department of Transportation.)

It all worked well, day and night, until December 7, 1941, when the United States entered World War II. Within months gasoline and tire rationing dried up the traffic. Sometimes the boats left with a nearly empty car deck. Sometimes they sailed completely empty. Guards were placed on the docks and near the ships to prevent possible enemy sabotage, and for Americans everywhere, life suddenly changed. (Michigan Department of Transportation.)

Six

WORLD WAR II DOWNTURN

Republican Charles M. Ziegler had been deputy highway commissioner under Frank Rogers. He ran unsuccessfully against Murray Van Wagoner. He ran again and beat G. Donald Kennedy to become highway commissioner in 1943, assuming the post early, because after his loss, Kennedy resigned. Ziegler entered the department to find it decimated by the war effort. Too many engineers had been drafted and there was no money to do any work. (Michigan Department of Transportation.)

Charles M. Ziegler determined that, although construction on the new causeway/ferry dock had been held up by the war, it would not resume again. His engineers felt it was unusable as a dock, as the weather was too bad too often out on the end. He produced expert testimony designed to support that idea. And he set about a review of every contract his department had. (Michigan Department of Transportation.)

Since hardly any traffic was using the ferries, *The Straits of Mackinac* and the *City of Cheboygan* were all that was needed to handle straits service. Troy Browning, born into a steamship family, had the idea to use ferries to haul truck trailers between Detroit and Cleveland on Lake Erie, saving rationed tires and fuel, and freeing truck drivers for other jobs in the war effort. (Michigan Department of Transportation.)

After the contract review, Ziegler leased the *City of Munising* and *City of Petoskey* to Browning's newly formed Trucker's Steamship Company. Many laid-off crew members went along. While it seemed like a good idea to Browning, and most observers, it did not seem like a good idea to the Teamsters Union. Members protested vigorously, and soon Trucker's Steamship Company failed. Within a year, the ships were returned. (C. H. Truscott collection.)

With hardly any traffic, the larger boats were not really needed. But what was needed were the two railroad icebreakers, which the government ordered to keep shipping lanes open so iron ore could get to lower lake steel mills for the war effort. The *City of Cheboygan* at times was forced to run in winter ice, even though she had difficulty doing it. (Michigan Department of Transportation.)

The Straits of Mackinac's upper automobile deck was another war casualty. It was removed and donated to a scrap drive because the highway department determined she could run more efficiently by loading the lower deck and sailing, rather than using the elevator to load the upper deck one car at a time. Without her upper deck, the elevators were used only for storage, and bird nests. (Author's collection.)

Both the *Chief Wawatam* and *Sainte Marie* (II) were very busy during the war years. Not only did they help keep shipping lanes open all over the Great Lakes, they also continued to ferry cars, trucks, and railroad equipment across the straits when they were available in the area. In this winter view, the *Chief Wawatam* approaches Mackinaw City after a snowstorm. (Michigan Department of Transportation.)

The rail ferries were excellent icebreakers and helped the war effort, but they could not be everywhere. The *Chief Wawatam* was called to eastern Lake Erie to rescue an injured sailor. The big ferry also went into Lake Superior through the Soo Locks. But when one was on an icebreaking mission, sometimes the other boat was too. (Michigan Department of Transportation.)

The car ferries were not the only icebreakers on the lakes when the war started. But they were about the only ones that stayed there. Other ships like the Coast Guard cutter *Escanaba* were called to the North Atlantic, for any government ship with arms was needed to escort convoys. The *Escanaba* never returned. She was sunk while on duty, and lost nearly all her crew. (Michigan Department of Transportation.)

Realizing the importance of the year-round straits connection for the war effort, and also seeing how much help the black railroad boats were elsewhere during the winter, Michigan legislators pushed a bill through congress to appropriate money for a new Great Lakes super icebreaker. The *Mackinaw* was launched in 1944 and quickly proved her worth. This is an L. L. Cook postcard. (Author's collection.)

The *Mackinaw* was the most powerful ship on the Great Lakes and could handle most ice conditions with ease. Her designers made sure she would always be where she was needed too—with a designed beam of 75 feet, the big cutter was locked in the Great Lakes. Her hull was too wide to fit through the existing lock systems to ever reach the open ocean. (Michigan Department of Transportation.)

Seven
NEW BEGINNINGS

As the war ended, rationing was lifted, and American motorists quickly made up for lost time. As hundreds of cars jammed the ferry docks the first weekend with no restrictions, ferry officials launched a plan to speed service across the straits. The *City of Munising* was taken to the shipyard, and an opening bow seagate was installed. The detail seen here is from an L. L. Cook postcard. (Author's collection.)

The open bow allowed the ferry to unload from either end. Motorists no longer had to drive down one side of the deck and back up the other, but could drive on one end and off the other. The arrangement saved about 10 minutes per round trip, although the ship still had to turn around either before or after loading. It also increased the ship's capacity by a car or two. (Author's collection.)

The modification was so successful on the *City of Munising* that the other two end-loaders were quickly scheduled into the shipyard for the same changes. It looked like it would be necessary. Since nothing had been done with the causeway/dock project since the war started, the governor reluctantly dismissed the Mackinac Bridge Authority that had been building it. This is an L. L. Cook postcard. (Author's collection.)

In order to match the stern at the apron, the front of the bow had to be squared off. The crews called the addition, "the bustle." The sharp corners on the bow made for some difficult forward landings. It was easy to hook the bustle into a cluster of pilings, either throwing the landing off course, or splintering wood all over the forward car deck. (Michigan Department of Transportation.)

Keeping a coal fired steamboat bright and shiny white was no easier after the war. Crews were kept busy all the time washing, cleaning, and repainting nearly every surface on the ship. While in dry dock, the *City of Petoskey* got her name repainted on the bridge below the pilothouse windows. (Michigan Department of Transportation.)

Heavy traffic in 1948 meant the new diesel icebreaker could at last be justified. Here the *City of Cheboygan* unloads at State Dock No. 2, while *The Straits Mackinac* awaits a call to duty. Her small capacity limited her to use only on the busiest days. So her always-on-duty crew referred to her as the "Good Ship Lollypop," a reference to a Shirley Temple song. (Michigan Department of Transportation.)

The year 1948 was the 25th anniversary of Michigan State ferries. The state highway map that year featured the *City of Petoskey* on the cover, and St. Ignace merchants issued a 25¢ trade token, good at participating merchants for the rest of the summer, and a huge weekend celebration was planned for the height of the tourist season, in mid-August. (Author's collection.)

To bring the celebration to the rest of the state, the highway department created a traveling exhibit booth in the form of a stylized pilothouse from the *Ariel*. The booth made a tour of county fairs and community festivals across Michigan for most of the summer, drawing praise and building excitement for the celebration to come. (Bentley Library, Ziegler papers.)

The three-day celebration kicked off with commissioner Charles M. Ziegler welcoming everyone to the big weekend in St. Ignace. A stage was set up in the State Dock No. 1 parking lot, and most of the activities were directed from there. Ziegler recognized employees who had been there the longest, including Elmer Paquin, who had been there all 25 years. Ziegler also introduced the royal court for the event. (Michigan Department of Transportation.)

87

During the day there were speedboat races, softball games, live radio broadcasts recreating a Detroit Tigers away game, an Air National Guard fly-by, and a sanctioned swimming race to Mackinac Island. Most of the contestants dropped out, but several including Dave Pushman of Detroit held on to make it all the way. He did it in 2 hours, 22 minutes. (Michigan Department of Transportation.)

The queen and her court reigned over all the activities that weekend. Here they pose onboard the *Mackinaw*. Visitors were asked to vote for which contestant would make the best queen at area stores, the votes were tabulated, and the big 25th Anniversary Coronation Ball was held on Saturday night, on the stage at State Dock No. 1. (Michigan Department of Transportation.)

On Friday evening, Michigan's governor Kim Sigler officiated on a VIP buffet dinner cruise aboard the Coast Guard cutter *Mackinaw*. Special guests, politicians, the royal court, and the media were all treated to a meal and the cutting of the special 25th anniversary celebration cake. Actually there were two of them, because there were so many guests. (Michigan Department of Transportation.)

That night the car deck of *The Straits of Mackinac* was turned into a giant dance floor, as the public was invited to sail on a sold-out moonlight dance cruise around Mackinac Island. A total of 300 couples danced the night away under a perfectly clear sky with a big white moon that only escalated the mood of the day. The cruise lasted until long after midnight. (Michigan Department of Transportation.)

For some, the highlight of the weekend was seeing the royal court wearing bathing suits while riding the Michigan State ferries float in Saturday's parade. For others, it was the first glimpse of the models representing the new icebreaker that adorned the float. The plans had been released just weeks before, and another model was on display downtown. (Michigan Department of Transportation.)

The model represented the latest plans for the ship, but bids came in too high again, and the governor rejected them all. There was too much traffic at the straits to be ignored any longer, however, so in a bold move, the Michigan State Administrative Board overruled the governor's veto, and funding to begin building the new icebreaker was finally available, to begin construction in 1949. (Dossin Great Lakes Museum.)

Eight
VACATIONLAND

The concept-art design that was released for the new ferry differed significantly from the models the public had seen earlier. Someone made the decision to use smaller Great Lakes–style pilothouses, instead of the wide open style that could see both sides of the ship and the bow while icebreaking. Some ferry workers blamed commissioner Charles M. Ziegler for the decision, but it was likely economics. (Author's collection.)

Built by Great Lakes Engineering Works in River Rouge, hull No. 296 was 360 feet long and 75 feet wide. It was powered by four manganese bronze propellers, each 12 feet 3 inches in diameter. They were turned by four Nordberg TSM-2184 eight-cylinder diesel engines, the largest Nordberg had built up to that time. The shafts were each connected by 10-ton Westinghouse electromagnetic couplings. (Michigan Department of Transportation.)

As commissioner Charles M. Ziegler (right) looked on, the new ship was christened April 7, 1951, by his 14-year-old daughter Barbara Ann, assisted by Charles Haskell, the shipyard president. With the words, "I christen thee *Vacationland*," the traditional champagne bottle was broken over the ferry's rudder, and she slid down the ways into the Detroit River. (Michigan Department of Transportation.)

With the touch of an unseen button, the heavy 75-foot-wide hull started moving for the fist time, splashing into a waterway that was only 105 feet wide. Soon the hull was towed to a fitting-out berth, and construction of her superstructure began, by putting sides on the car deck big enough to hold 150 automobiles of the day. Unfortunately this original print was damaged in processing. (Michigan Department of Transportation.)

Fitted above the car deck were two large passenger lounges, one on each end of the double-ended ferry. Between the lounges were accommodations for a full compliment of live-aboard crew members, including a galley, mess rooms, and staterooms for officers and crew. Unlike many Great Lakes vessels, *Vacationland*'s crew would all live off the same corridor. (Michigan Department of Transportation.)

93

The next deck up, the boat deck, would be fitted with a pair of pilothouses, a fiddley for the twin funnels, and six 25-man lifeboats with davits. When finished, the pilothouses would be trimmed with a distinctive visor sweeping back into a curved side of the chart room, and flowing all the way down to the deck. While stylistically pleasing, the small windows made them poorly functional. (Michigan Department of Transportation.)

Construction moved quickly, and by August 1951, *Vacationland* was beginning to look like her final form. The ferry would be painted gleaming white to match the rest of the state ferry fleet. By the end of September, crew members were beginning to move in, to learn systems and to finish all the minor details a newly built vessel requires. (Michigan Department of Transportation.)

With the shipyard tug *Florida* at her bow, and another at the stern, *Vacationland* was prepared for sea trials in the early morning of December 8, 1951. Since she was a double-ender, each test had to be run twice, meaning invited guests stayed aboard for nearly 22 hours. This view was cropped and reproduced on millions of postcards over the years. (Michigan Department of Transportation.)

With *Vacationland* expected at any moment, the state had not renewed the lease on the *Sainte Marie* (II), so everyone was glad when the new ship made her way, without navigational aids, through the ice to St. Ignace, arriving on the morning of January 12, 1952. Along the way, schools dismissed classes and motorists clogged waterfront highways to catch a glimpse of her. (Michigan Department of Transportation.)

When *Vacationland* arrived, she did not go to State Docks No. 1 or No. 2, as neither was large enough to fit her. Instead she sailed directly to a huge brand-new State Dock No. 3, which had been constructed at the old "furnace site" over the last summer. The site was much closer to Mackinaw City, shaving about 10 minutes off the original run and eliminating backups into downtown. (Author's collection.)

State Dock No. 3 featured two end-loading slips and a side-loading slip for *The Straits of Mackinac*. In the center of a parklike area was a flagpole that held range lights aligned with each end-loading slip. There was a huge, off-street holding area for vehicles (at left) and easy access to the state highways, via Ferry Lane, a new limited access two-lane road curving off in the distance. This is an L. L. Cook postcard. (Author's collection.)

By the time *Vacationland* went into service, there was also a new slip for her in Mackinaw City. It had been built at the north side of the triangle extension and included a new electrically controlled apron that not only moved up and down, but in and out to accommodate different size vessels and varying ice conditions. It also had a fuel island adjacent to the apron. (Michigan Department of Transportation.)

The facility included a storage tank farm for diesel fuel and lubricating oil to keep the ship operating all winter. It was located on land, just north of the head of the dock and connected to the slip by a heated, insulated pipeline. Altogether, the ship, docks, and facilities had cost the State of Michigan nearly $7 million. It was an investment planned to last a long time. (Michigan Department of Transportation.)

Vacationland rests in her Mackinaw City slip while the *City of Cheboygan* departs for St. Ignace. This will be a light load for the big ferry. She will easily accommodate all the vehicles on the dock, including the two trucks with new cars destined for Upper Peninsula buyers. This view shows the long insulated pipeline that carried fuel and oil to the side of the slip. This is an L. L. Cook postcard. (Author's collection.)

The second most powerful ship on the Great Lakes, after the *Mackinaw*, *Vacationland* was quite successful as an icebreaker, getting seriously stuck only once, in April 1957, when moving ice drove the huge ship aground. She was freed after 22 hours and towed off by the *Mackinaw*, assisted by two other cutters. A total of 66 passengers had spent the night onboard. This is an L. L. Cook postcard. (Author's collection.)

Nine
BRIDGING THE GAP

In 1949, 36-year-old Democrat G. Mennen "Soapy" Williams became Michigan's governor, setting up a long-running conflict with Republican highway commissioner Charles M. Ziegler. Heir to the Mennen toiletries fortune, Williams always sported a trademarked green polka-dot bow tie. He also looked quite favorably on the idea of bridging the straits and welcomed other supporters of the plan. (Michigan Department of Transportation.)

In 1950, even before the *Vacationland* and her new docks were completed, G. Mennen Williams signed a bill recreating the Mackinac Bridge Authority. Over the next few years, the group, headed by former senator Prentiss Brown, worked tirelessly to fund, design, and build a bridge across the straits. The biggest hurdle was met in 1954, when they finally sold the bonds to do it. (Bentley Library, Ziegler papers.)

Later there were those who felt commissioner Charles M. Ziegler was against the bridge. He was only against having his department pay for it, with no budget. He appears on the far right of the top photograph, taken from his personal scrapbook, and he appears second from right in this photograph with, from left to right, bridge engineers D. B. Steinman, O. H. Ammon, and G. B. Woodruff. Steinman ultimately got the designing job. (Bentley Library, Ziegler papers.)

Even though construction for the bridge quickly got underway, the ferries kept on running normally, as people still had to cross the straits. Some people apparently crossed in cars older than others, as deckhands discover as they prepare to unload the *City of Munising* on arrival at Mackinaw City. Note the car directly behind the deckhand removing the safety chain. (Author's collection.)

The calm of downtown Mackinaw City would soon change, however, as thousands of job seekers flooded Northern Michigan looking for work on the soon-to-be-built bridge. Unfortunately for them, most early work took technical skills they did not have. The *City of Munising* is seen in the background about to arrive at the dock, while the Great Lakes cruise ship *South American* is visible heading for Mackinac Island. This is an Hiawatha Card Company postcard. (Author's collection.)

The first construction was below the water, building the huge foundations needed to support the bridge. The ferries were joined on the straits by one of the largest flotillas ever assembled in peacetime, making marine traffic even more congested in the narrow waterway than normal. Staging for much of the construction was done from the old causeway extending south from Pte. LeBarbe. (Mackinac Bridge Authority.)

In the winter, when the straits froze, the flotilla retreated to shelter near St. Ignace. Only the railroad ferries and the *Vacationland*, crossing every day, were able to keep an eye on the work done the first summer of bridge construction. Passengers could see the many ships in the summer, but there was little to see during the winter months at first. (Mackinac Bridge Authority.)

Summers were a different matter, especially when the bridge superstructure began to rise. The closer the project came to completion, the more people came to see it. While local boat owners and island ferry operators offered tours to the site, the least expensive view from the water was on the deck of a passing Michigan state ferry. (Bentley Library, Ziegler papers.)

Whenever the weather permitted, people crowded the decks, many with cameras in hand, to record every nuance of the bridge construction. Displays were set up along the shore, along with dozens of coin-operated telescopes so people could watch the bridge workers close up. Several businessmen even built special viewing platforms so land based tourists could get a better view. (Richard L. Weiss collection.)

Many families brought children, not only to watch the passing parade, but because they knew that when the bridge opened the ferries would be gone, and they wanted their kids to have one last opportunity to say they had been aboard a Michigan State ferry. It is the people who rode as children then, who mostly remember riding the boats today. (M. J. Elzinga collection.)

Things were a little more somber for ferry workers who knew their jobs would end when the bridge opened. Still, with all the passengers on deck, there was time for off-duty crew members to have a little fun, get a little fresh air, and watch the public passing by. Crew members also knew where gusts of wind could catch unsuspecting women's skirts! (M. J. Elzinga collection.)

Here are some of the tickets actually used aboard the Michigan State ferries. The top ticket dates from 1949, when it cost $1.75 to take an automobile across. Once the bridge was set to open, the fare was raised closer to the bridge toll, $2.50, as shown on the bottom receipt. The middle stub is for a passenger fare, 50¢. The bottom two tickets were issued in 1955. (Author's collection.)

In 1956, the highway department issued the last-ever Michigan State ferries schedule (left), which combined sailing times for both 1956 and 1957, the final year of operations. The bridge was scheduled to open November 1, in time for hunting season, and commissioner Charles M. Ziegler saw no reason to print the winter schedule twice. (Author's collection.)

105

The schedule would also be one of the last documents to list Charles M. Ziegler as highway commissioner. After serving longer than anyone, except Frank Rogers, Ziegler retired with his term, at the end of June. He planned to kick back and spend time fly-fishing at his cabin in West Michigan. It is said that since his youth, he could accurately cast two flies simultaneously. (Michigan Department of Transportation.)

Ziegler's handpicked successor lacked his charisma and was defeated in the 1956 election by Democrat John C. Mackie, who was sworn in on July 1, 1957, just four months before the ferry service was scheduled to end. It would fall to Mackie to close down the ferry operation, dispose of the fleet, and try to find work for all the displaced employees. (Michigan Department of Transportation.)

Many crew members pinned hopes on a proposal to run the boats from Frankfort to Menominee, across Lake Michigan, and they circulated a flyer to solicit support from the public. But their hopes were dashed when the state attorney general ruled any state-run ferry between peninsulas was contrary to the covenants in the new bridge bonds. (Michigan State Archives.)

Soon after taking office, commissioner John C. Mackie visited the state ferry office in St. Ignace to discuss future employment with the soon-to-be displaced workers. He made it a priority to find work elsewhere in his department for as many people as possible and to help those who needed a high school equivalency exam. When the ferries ended, over 75 percent of the workers had already found new jobs. (Hy-Lighter, Michigan State Highway Department.)

The last full day of ferry operations was October 31, 1957. The fleet was very busy, as people from far and wide took one last ride on an institution many of them thought would always be there. *Vacationland*, which had cost over $4.5 million just six years before, and the rest of the fleet faced an uncertain future, as did the communities the ferries served. (Bentley Library, Ziegler papers.)

As the sun set on one institution, it rose on another. On November 1, 1957, Gov. G. Mennen "Soapy" Williams, commissioner John C. Mackie, and other dignitaries opened the Mackinac Bridge to traffic. It has provided a solid link between the people of Michigan for 50 years, and the bond continues to grow. Today the bridge carries as many people in some months as the ferries did in many whole years. This is a detail of a postcard photograph taken by Benjamin.

As part of the opening ceremonies for the Mackinac Bridge, the City of St. Ignace sponsored a closing ceremony for the ferries. Hundreds gathered around the State Dock No. 3 flagpole to cheer ferry crews and introduce longtime employees one last time. Meanwhile VIP automobiles line up in the foreground for a special invitational "last trip" aboard the *Vacationland*, led by Williams's sedan. This is an L. L. Cook postcard. (Author's collection.)

Special invitations were printed for guests to take the last trip with the governor on *Vacationland*, one kind for automobiles and another for foot passengers. Most people ignored the invitations and showed up anyway, and some got on. Newspaper reports of the day said that on the last trip, the big ferry carried 84 automobiles. The crew had a hard time keeping passengers from stealing things for souvenirs. (Author's collection.)

St. Ignace mayor Alexander G. Phillips hosted the ceremony, and the mayor of each community for which a ferry was named presented that boat's captain with a plaque to be mounted on his vessel, commemorating its years of service, and scrolls to be "logged" on each vessel. Afterward *Vacationland* loaded and left for the last ferry crossing of the straits. (Michigan Department of Transportation.)

But while even people without invitations crowded aboard the big ferry for the "last" trip, most never knew they did not really have that honor. The next morning, November 2, *Vacationland* made one more crossing from Mackinaw City to St. Ignace. With only her crew aboard, she delivered the remaining equipment and supplies from her dock to the ferries warehouse then returned to Mackinaw. (Author's collection.)

Ten
SAILING AWAY

This L. L. Cook postcard from late 1957 is titled *Faithful Ferryboats*. After serving travelers between Michigan's peninsulas for 34 years, the faithful Michigan State ferries were tied up and offered for sale. The *City of Cheboygan* and *City of Petoskey* were on one side of State Dock No. 2 in St. Ignace, as seen here, and the *City of Munising* and *The Straits of Mackinac* were on the other. (Author's collection.)

Michigan used *Vacationland* just one more time. In July 1958, she was used as a barracks to house state policemen, there for crowd control at the bridge's "official" opening. Civic leaders feared poor November weather would hurt attendance, so they waited until the next summer for the big day. November 1957 was warm and dry. The chosen summer weekend was cold and wet. This is a Hiawatha Card Company postcard.

While the highway department tried time and again to sell the ferries, people went about their daily lives, made simpler with the bridge. This 1960 L. L. Cook postcard of St. Ignace's Marquette Days celebration clearly shows the laid up ferries at State Dock No. 2 in the background. Only *The Straits of Mackinac* has steam up, as she had just been sold. But what happened to all the ferries? (Author's collection.)

Michigan's first state ferry, the *Ariel*, was sold in 1926 for use between Port Huron and Sarnia, Ontario. In 1937, the Blue Water Bridge retired most of the fleet, but Michigan got her back briefly for use as a passenger ferry until bridge bus service could be established. After that, she was laid up in Port Huron for several years. (Author's collection.)

This old newspaper photograph tells it all. *Ariel* was purchased in an attempt to make a floating restaurant, and moved to Detroit, almost to the spot where she was built. But for many years, nothing more was done. In 1948, a wind and rainstorm sunk the old ferry at her dock. She was raised, but considering her age, was judged a total loss and was dismantled. (Mackinaw City Public Library.)

When the *Mackinaw City* and *Sainte Ignace* were sold back to the federal government in 1940, they became the *Brig. Gen. Wm. Horton* and the *Brig. Gen. Arthur W. Yates* respectively. In 1941, they were both converted to burn oil. When World War II ended, they were resold as surplus and although they were stationed on the east coast, reverted to the names they used in Michigan. (Monmouth County Historical Society.)

The Keansburg Steamship Company of New Jersey bought them on speculation, hoping to either resell them at a profit, or convert them to passenger vessels for 1,175 people, or ferries for 600 people and 50 cars. But those plans were dashed when a hurricane blew them aground on November 25, 1950. It was easier to sell them for scrap, and they were both gone by 1954. (Monmouth County Historical Society.)

Edward Anderson was a potato grower and wholesaler from Washington Island, Wisconsin. He first purchased the *City of Cheboygan* in January 1959 and converted her to a barge, which he named after himself and used to process and transport his crops to market. He later purchased the *City of Munising* for the same purpose and called her "No. 2." The barges were towed to Benton Harbor once a year. (Dave Christiansen collection.)

The plan worked well for several years. Then markets changed, and when he tried to convert them to process frozen french fries, the plan failed. After storing the boats for several years, when the price of steel went up in 1972, Anderson sold them for salvage. They were towed out the seaway, across the Atlantic, and scrapped in Italy that fall. (Al Hart collection; photograph by A. F. Sagon-King.)

115

Vacationland was finally sold in early 1960 to Detroit-Atlantic Navigation Corporation (DANCO), a firm started by Trucker's Steamship Company's Troy Browning. It was reorganized under former automobile magnate Carson "Jack" Dalton and hardware baron Stanley Carter. DANCO made a down payment on the ferry and planned to haul truck trailers between Detroit and Cleveland. The ship was rechristened *Jack Dalton* by Dalton's wife Ruth in early May. (Detroit News.)

DANCO started with great promise, making the first trip to Cleveland for a welcoming celebration with civic and shipping leaders. Painted gray and white with Ds adorning red bands on her funnels, the *Jack Dalton* was an impressive sight when she tied up at Cleveland's East Sixth Street pier. But in subsequent weeks, her sailings became more infrequent. (Cleveland Plain Dealer; photograph by Dudley Bumbach.)

The *Jack Dalton* was still the second most powerful vessel on the Great Lakes. DANCO hoped her icebreaking hull would allow truck trailers to be transported all year long, even when weather closed major highways on land. But the company never made it to the first winter. Her owner's grandson Carson Dalton III believes the Teamsters pressured shippers to withdraw from their contracts. (DANCO files.)

It may have been Teamster pressure or competition from the new Ohio Turnpike, but DANCO did even worse than Trucker's Steamship Company. By late July the ship was laid up again, this time in Detroit. The crew was sent home, and with no income, DANCO was unable to make installment payments. Michigan repossessed the ferry and again offered her for sale. (Detroit News.)

With no prospects apparent for the 60-year-old *City of Petoskey*, the State of Michigan gave up and sent her to scrap in 1961. The oldest vessel in the ferry fleet, she and the *City of Munising* had originally been sold to K&K Trucking of Montague, Michigan, for truck trailer service across Lake Michigan. But the Interstate Commerce Commission denied K&K's permits, so the deal fell through. (Al Hart collection.)

The *City of Munising* was resold to Edward Anderson, but there was no interest in the *City of Petoskey*, so she was towed to Ashtabula, Ohio, where she was dismantled (seen here and above). About the same time, MTC sold the *Sainte Marie* (II). The state no longer leased her each winter, and the *Mackinaw* now did the icebreaking. Sold to a new ferry line in Ashtabula that never developed, she was soon dismantled there too. (Al Hart collection.)

In 1961 the *Jack Dalton* was at last sold again, and towed to a shipyard in Ontario, where a restaurant, bar, and gift shop were added to her lounges. She was renamed *Pere Nouvel* and registered in Canada for automobile ferry service across the St. Lawrence River, by the North–South Navigation Company, of Rimouski, Quebec. Her new route would take her to Baie Comeau on the river's north shore. (Al Hart collection.)

There was no nearby ferry service on the river, and the demand was huge. When the *Pere Nouvel* made her maiden voyage to her terminal at Pointe au Pere, near Rimouski, thousands crowded the dock to welcome her, and traffic backed up for miles. The crowd waited for hours to climb the temporary gangplank and tour the vessel since loading ramps had yet to be constructed. (North–South Navigation.)

Pere Nouvel made one trip a day across the St. Lawrence, and ran completely full every trip for the next five years. North–South crew members became a truly happy family living onboard the big ferry, while serving travelers with no other convenient way to cross the river. Occasionally she was delayed by bad weather, but her service was extremely valuable to the communities she served. (Author's collection.)

North–South was the idea of Charles Aristide Girardin. His wife, Gabrielle, named the ship for Fr. Henri Nouvel, the first missionary on the river's north shore. But the financing came from a heavy equipment dealer and a $5 million, five-year subsidy from the government. When the subsidy ran out, the equipment dealer withdrew his support, and despite apparent annual profits, the ship was offered for sale. (North–South Navigation photograph.)

In 1967, the *Pere Nouvel* was purchased by the government of British Columbia and sailed through the Panama Canal to Canada's west coast. She was modified with platform decks to increase automobile capacity to over 175 cars and bow extensions to fit BC Ferries' existing terminals. With larger passenger lounges, she was renamed *Sunshine Coast Queen* and used between North Vancouver and Langdale, across Howe Sound. (Photograph by Frank Clapp.)

From 1968 to 1977 the "Suzy Q" made five crossings a day, ferrying commuters and tourists to British Columbia's Sunshine Coast. She was popular with both passengers and crew, but her heavy icebreaking hull and added weight made her very fuel inefficient, and engine parts became harder to find. BC Ferries replaced her with a larger more efficient vessel and offered her for sale. (Commercial Illustrators, Ltd.)

Originally purchased in 1981 for use as an oil drilling support ship on Alaska's North Slope, *Sunshine Coast Queen* was renamed *Gulf Kanayak*, but the deal fell through, and despite changing owners and tie up locations several times, no further economical use was found for her. She was left to vandals and slow deterioration in the Frasier River, near Vancouver. (Photograph by Ed Whitebone.)

In 1987, she was sold to a Washington company and prepared for scrapping in China. Entering the Pacific, the tugboat encountered an early-winter storm with high winds and waves. The ferry started taking on water, but it was too rough to save her. The former *Vacationland* slowly sank the night of December 3, 1987, about 100 miles from shore in water over 2 miles deep. (Author's collection.)

The Straits of Mackinac was sold in January 1959, to Straits Transit, a firm owned by 15 local straits area residents, including 10 former ferry workers. They used her to carry passengers to Mackinac Island, first from St. Ignace, and later from Mackinaw City. *The Straits of Mackinac* dwarfed the other ships on the run, and carried on the "State tradition" for several years. (Author's collection.)

As her owners aged, the cost of operating a coal-fired steamboat rose. Straits Transit reluctantly needed to economize, and on Labor Day, 1968, *The Straits of Mackinac* made her last island run. She was laid up in the Cheboygan River and offered for sale. The company replaced its 20-man steamboat with a new diesel vessel named *Straits of Mackinac II*, with a four-man crew. (St. Ignace News.)

Purchased by Peterson Builders, a shipyard in Green Bay, Wisconsin, *The Straits of Mackinac* was first used as a dormitory for sailors stationed at the yard. Her car deck also made a good location for floating storage. But time took a toll on her wooden superstructure, and it slowly deteriorated, making it unsafe to use. (Dave Christiansen collection; photograph by Wendell Wilke.)

For safety, Peterson dismantled the wooden portions of the ship over a period of time in 1975. Remarkably, the cabins, engine room, and boiler room located below deck remained in good condition right up until the end. She slowly deteriorated in the elements at Peterson's yard for several more years, until ultimately sold. (Dave Christiansen collection; photograph by Wendell Wilke.)

A private buyer took the remains of *The Straits of Mackinac* to Kewaunee, Wisconsin, seen here. But he died before anything could be done. Evicted from her repose for a marina, several diving clubs worked tirelessly to remove contaminants so she could be scuttled as a scuba diving attraction. She was last moored in the Calumet River in Chicago, where the work was completed. (Dave Christiansen collection; photograph by William H. Rieschl.)

After clearance by all the proper authorities, poor weather held up the move, but finally, in 2005, *The Straits of Mackinac* was towed to a location about 14 miles northwest of Chicago's Navy Pier, and sunk in 80 feet of water. Today she has become a major diving destination on the Great Lakes and a growing habitat for marine life. (Photograph by Patrick Hammer.)

When the MTC filed to abandon rail ferry service, the State of Michigan took over the *Chief Wawatam*. But the St. Ignace dock collapsed in 1985, and service was suspended. The *Chief Wawatam* was laid up in Mackinaw City until 1989, when, despite protests from preservationists, she was sold to Purves Marine of the Soo, and reduced to a barge. She occasionally makes appearances at the straits today. (Photograph by Skip Natzmer.)

The mighty *Mackinaw* was an active duty icebreaker for over 60 years. In 2006, she was replaced by a new vessel of the same name, and moved to the *Chief Wawatam*'s old slip in Mackinaw City, where she is being developed as a museum of icebreaking and of the ships that plied the straits so long ago. The state dock there is being developed as a marina. (Author's collection.)

The ferries do not land here anymore. The boats have all gone. The people who worked here moved on. But half a century later, the ferry docks still stand as mute testimony to a day, long ago, when Michigan's peninsulas were connected by the men and women and boats of the Michigan State Highway Department's "Highway on the Water." For some, the memories also remain. (Photograph by the author.)

Across America, People are Discovering Something Wonderful. *Their Heritage.*

Arcadia Publishing is the leading local history publisher in the United States. With more than 3,000 titles in print and hundreds of new titles released every year, Arcadia has extensive specialized experience chronicling the history of communities and celebrating America's hidden stories, bringing to life the people, places, and events from the past. To discover the history of other communities across the nation, please visit:

www.arcadiapublishing.com

Customized search tools allow you to find regional history books about the town where you grew up, the cities where your friends and family live, the town where your parents met, or even that retirement spot you've been dreaming about.